U0003171

Mateusz Urbanowicz 手繪作品集 II
The Artworks of Mateusz Urbanowicz II

Tokyo at Night

東京夜行

Mateusz Urbanowicz 著
マテウシュ・ウルバノヴィチ

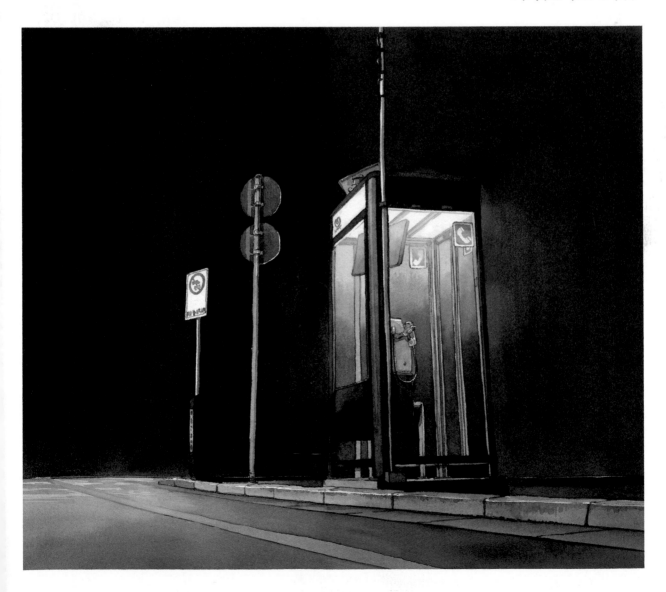

前言

「對於我而言，夜晚似乎比白天更充滿活力，更色彩繽紛。」
————文森‧梵谷〈寫給西奧的信〉於亞爾，1888 年 9 月 8 日

傍晚的城市慢慢地，但清晰地轉變成不同的模樣。道路變得狹窄，聳立的大樓好像是遙遠的黑暗城堡，變得更加神秘。

我為了在動畫公司工作而搬到東京，剛搬來的時候不認識任何人，也不認識這座城市。我只知道買畫具和鉛筆要去新宿，看漫畫要去秋葉原，買賣書籍要去神保町，這些是我知道的全部。

日常的壓力幾乎將我吞噬，於是我每天都會在工作結束後回到單房公寓，放下公事包，漫無目的地在夜晚的街道上散步。

雖然有時候我走得很快，周圍的景色也跟著消失在記憶的遠方，但大部分時候我都是放慢腳步，邊走邊品嘗夜晚的空氣。

明亮但人不多的街道讓我想起十歲左右某個晚歸的夜晚，我坐在雙親車子後座當時的心情。從車內瞥見亮著光的窗戶，眺望沒有人的明亮街角。在陌生的街上，鄉愁、憧憬、魅力等多種情感向我襲來。

每轉過一個街角就可以看到新的景色，讓我有一種雖然人在這座城市卻又好像不在的奇妙感覺。就好像是在黑暗的房間裡看著一張張播放的投影片，從一條街到另一條街，從一棟房子再到另一棟房子。

我剛來到東京的時候或許稱不上幸福。然而，夜晚喧囂的街道反而讓我的心平靜下來，近乎冥想。

東京有許多夜晚，也有許多值得去走的街道。

與 KANA（作者的妻子）相遇，改變了我對這座城市的看法。就好像晚上開車兜風的時候，如果身邊有一個好伴侶，一切都會變得不一樣。我們一有機會就會一起散步，走在夜晚的街上。

我們工作的地點在九段下附近，住在早稻田，因此經常在神樂坂附近散步。不僅是營業到很晚的喧囂酒吧或是餐廳、俱樂部，我們也經常走進小路探險。

根據這些夜晚散步的經驗，我開始使用其實不適合用來重現街道氛圍的水彩，描繪夜景。

這部作品集的開端就是當時最初創作的十幅畫作。這是我對東京的夜晚和這座城市的感受所留下的紀錄。

"It often seems to me that the night is much more alive and richly coloured than the day."
——From: Vincent van Gogh, Letter to Theo van Gogh, Arles, 8 September 1888 ※

Dusk slowly but certainly transforms the city into something completely different. It makes it into a place more mysterious, with the streets seeming narrower and the office buildings towering ominously like dark castles in the distance.

When I moved to Tokyo to work at an animation studio, I didn't know anyone here and didn't know the city at all. I understood that I could buy my paints and pencils in Shinjuku and read comic books in Akihabara. I also knew that book trading went on in Jimbocho. That was essentially everything I had.

On the days when I felt the pressure of everyday life engulfing me, I would go back to my small one-room apartment after work. I would leave my bag and go for a night stroll in the city with no particular direction or plan.
Sometimes I walked fast without looking at my surroundings and lost in my thoughts. But most of the time, I would stroll, drinking in the atmosphere of the city night.

The lit but empty streets reminded me of how I felt when I was about ten years old and rode at night in the back seat of my parent's car as we came home late. Just looking outside for glimpses of bright windows and lit street corners with no-one there. I would feel these intense waves of nostalgia, longing, and fascination with places I will never know.

Every corner revealed a new sight to drink in. I was walking through the city and still felt a bit disconnected from it, watching it in a dark-room freeze-frame, street by street, house by house.

I guess I was not happy then, but Tokyo's never-ceasing night hum soothed my thoughts, allowing for something close to meditation.

There is a lot of night and even more city to walk through in Tokyo.

After I met Kana (my wife), my attitude to the city changed as a night car ride changes if there's someone great to keep you company. We also walked at night together whenever we felt like it.
Since we worked near Kudanshita and lived in Waseda, we often would end up strolling through Kagurazaka. The loud pubs and restaurants open until late in the night and multitudes of narrow side streets invited us to explore.
Based on those walks, I started to paint the first night scenes, trying my best to recreate that atmosphere using the ill-suited for this purpose watercolors.

Building on all these experiences, I decided to make an art album. It is an exploration of the night side of Tokyo but also my feelings towards the city.

※ [676 (679, 533): To Theo van Gogh. Arles, Saturday, 8 September 1888. - Vincent van Gogh The Letters]
(http://www.vangoghletters.org/vg/letters/let676/letter.html)

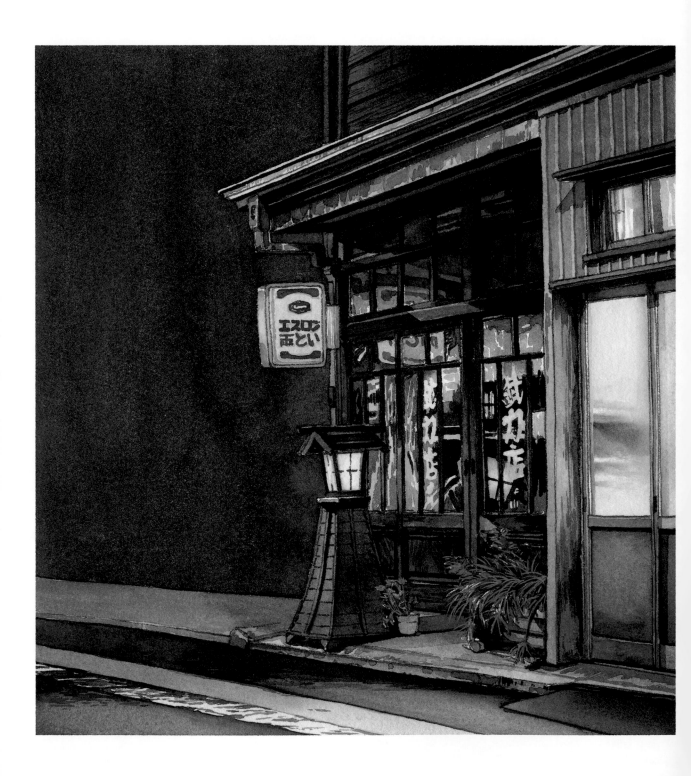

Contents 目次

Chapter 5
小巷子
Back alleys

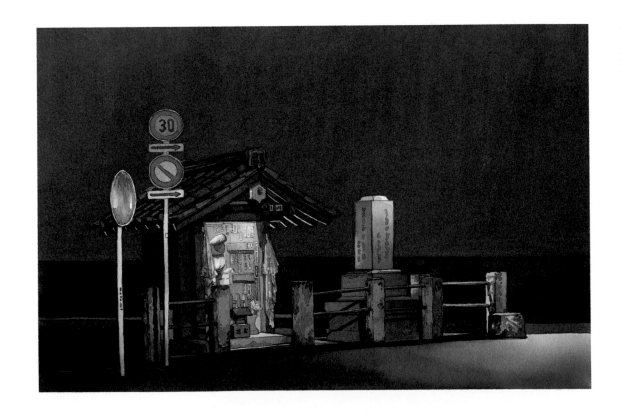

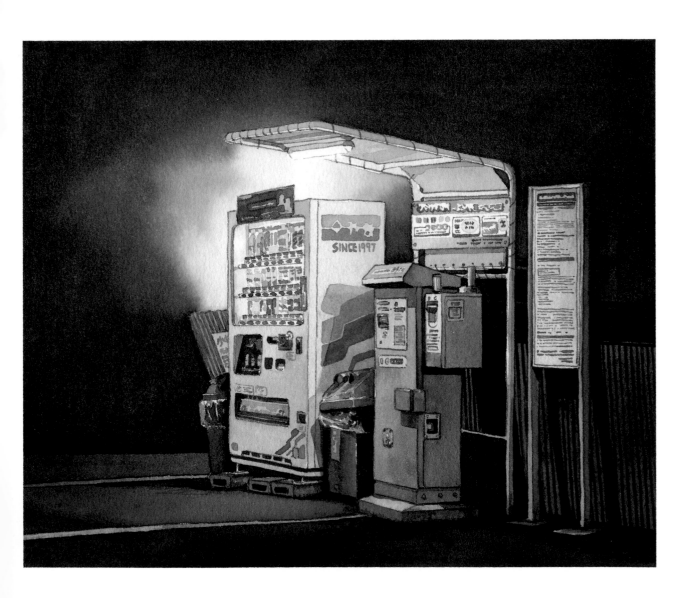

Chapter 1
High buildings 都會

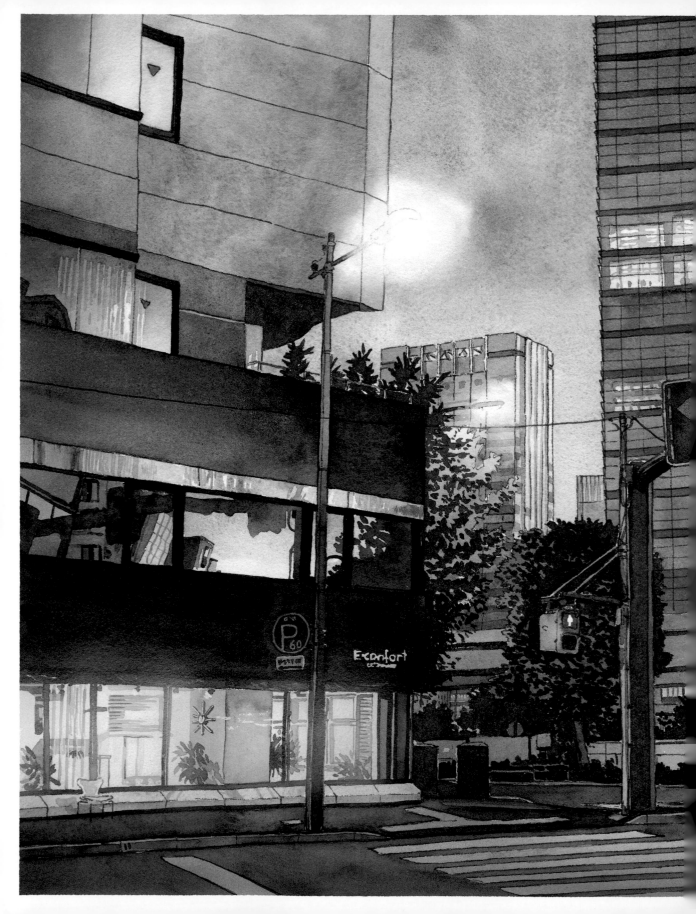

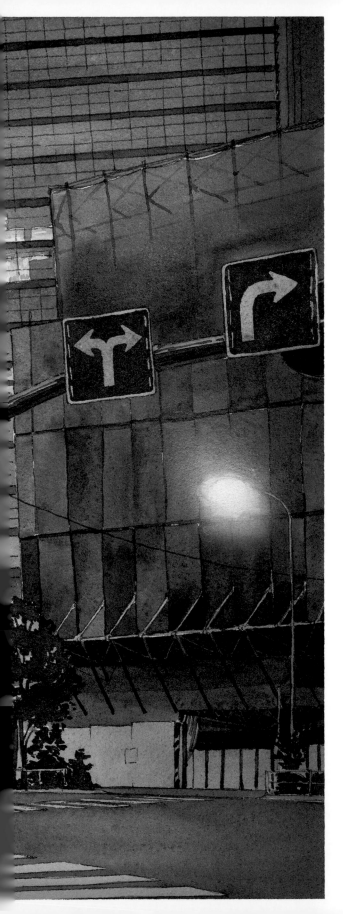

轉折點
被光線吸引

The turning point 01
Inviting lights

01 | 地點
東京都千代田区内神田 3 丁目。從龍閑橋的紅綠燈隔著外堀通仰望大手町的大樓。

Location
Uchikanda 3 chome, Chiyoda-ku, Tokyo. Looking up to buildings in Otemachi from Ryukan Bridge Intersection over Sotobori Street

描繪了什麼？

我們站在這個路口，不知道接下來要往哪裡走。想必不同的選擇會看到完全不同的風景。是時候做決定了，往右？還是往左？交通標誌告訴我們還有第三種選擇，但我們還是停下了腳步。

我的注意力被左邊的建築物吸引。淡藍色的天空映照在二樓窗戶❶上，看起來明亮又冷冽。一樓則是充滿溫暖的光線❷。這種質感和顏色創造出的反差，讓我想起過去看過的浮世繪版畫。同樣是灰藍色的夜晚，我總是會被閃耀著溫暖光線的窗戶吸引。我感覺眼前這幅景象也會帶來相似的故事。

What

We stop at this crossing not sure where to go next. Depending on my choices, we can meet with a completely different set of scenes. Time to make a decision: left or right. Can't go both ways, even though the signs seem to suggest otherwise.
A building on the left grabs my attention with the second-floor windows ❶ reflecting the pale-blue sky, bright and cold. To counter this, I see also a store, bathed in warm, gentle light. ❷ This lovely contrast of moods and colors reminds me of the old Tokyo woodblock prints I studied before starting to make this book. There too, in blue-grey night scenes, I would often see a bright window glowing with inviting light. I feel a similar story emanating from this place.

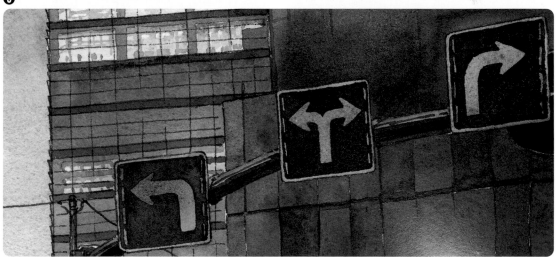

如何繪製？

　　在這幅作品當中，明亮的天空和反光創造出強烈的對比。為此，我對於上色的順序非常謹慎。上色之前，我首先用墨水描繪線條和最暗的影子。接下來用水彩從天空和窗戶等明亮的地方開始上色，最後畫出建築物外牆的紋理，以及覆蓋右側工地的塑膠布。

　　交通標誌 ❸ 有些棘手。首先必須一口氣畫出從暗紅色漸層到藍色的三個箭頭，呈現相同的色澤。接下來（乾了之後），小心地塗上深藍的背景色，讓箭頭的形狀更完整。

How

In this piece, the sky and some of the reflections are still really bright, creating a lot of areas of sharp contrast, so I had to pay much attention to the order of coloring. After the lines and flat shadows were done with the blue-black waterproof ink I started painting form the bright sky and windows followed by the darker, textured walls of the front and back buildings, finishing with the dark blue fabric construction site wall on the right.

The traffic signs ❸ proved to be a little finicky. I first had to paint the dull red and blue gradients that would become the arrows and then (after this wash dried) carefully paint around their shapes with the deep blue of the signs' background color.

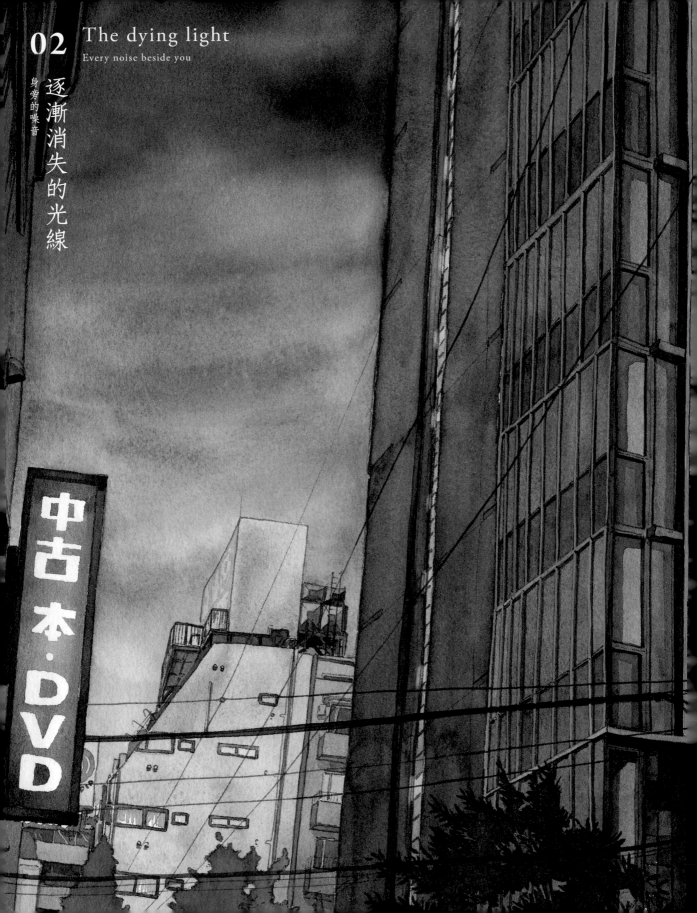

02

The dying light

Every noise beside you

身旁的噪音

逐漸消失的光線

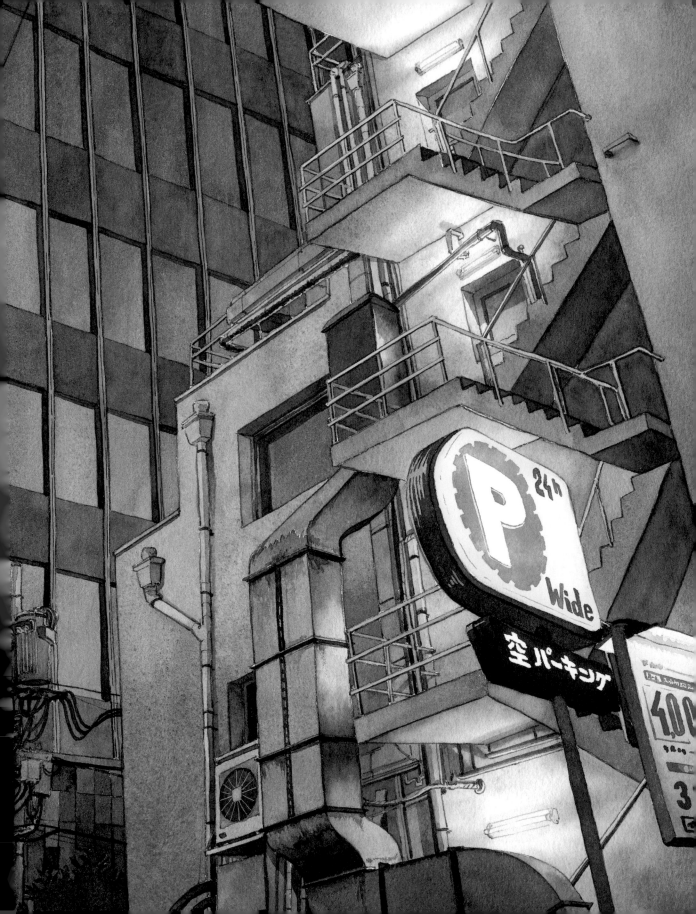

02 | 地點
東京都千代田区内神田 3 丁目。從神田車站延伸到西口商店街的小路。

Location
Uchikanda 3 chome, Chiyoda-ku, Tokyo. At a back alley off West Exit Shopping Street starting at Kanda Station

描繪了什麼?

周圍逐漸變得又暗又冷,但街道上還殘留白天的溫暖。第一次為了這個企劃外出取景的我們隨意地走在路上,希望可以從高聳的建築物當中找到有趣的風景。我試著聚焦各種高聳建築物所創造出的特殊對比。尤其是在建築物不斷被拆除重建的東京,緊鄰的建築物卻擁有完全不同的氛圍。這或許是讓這座城市看起來醜陋卻又十分有趣的原因之一。

與背景的建築物相反,照在樓梯上的燈光又白又亮。

看到形狀複雜的階梯❶和整齊的辦公大樓窗戶❷,我感覺這就是我要尋找的有趣對比。走近一看,我又發現停車場的招牌❸,為這個灰色平面的景色帶來亮點。於是我開始按下快門。

What

It is starting to get darker and colder even though streets still retain some of the warmth of the day.

We just embarked on our first location hunt for this project, walking randomly, looking for some exciting scenes among office buildings. I try to spot those unique contrasts and compositions that high-rise buildings often create. Especially in cities like Tokyo, where all the structures are continually being torn down and rebuild differently, even two neighboring buildings usually look apart. This is probably one of the things that make this city ugly and fascinating at the same time.

Lights on a staircase shine brightly against a dark building in back.

Looking at the complicated shape of the staircase ❶ against the clean, ordered window rows of the office building, ❷ I feel some of the unique contrast I'm looking for. Coming closer, I notice the parking sign ❸ creating a focal point for this grey scene and start taking photos.

❶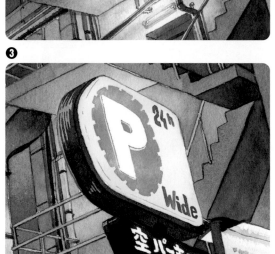

❷

❸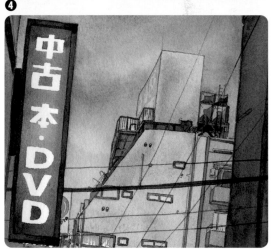

❹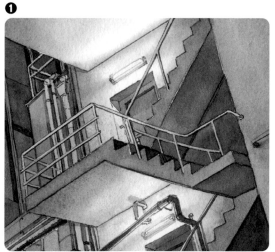

如何繪製？

這幅畫強調的不是光與影的對比，而是形與色的碰撞。我特別將有階梯的大樓 ❶ 畫得好像「依靠」在中央窗戶排列整齊的大樓上 ❷，營造有如廣角鏡一般的透視變形效果。接下來，我試著完整重現階梯的所有細節，加強兩棟建築物的對比。

為了讓停車場的招牌 ❸ 從灰色的背景中凸顯出來，我特別提高彩度，忠實呈現招牌原有的樣貌。與停車場的招牌不同，我不喜歡左側原有的招牌 ❹，因此改成簡單的「中古書・DVD」招牌。

我不想讓路樹看起來比大樓顯眼，因此不刻意描繪葉子，僅用深藍色的墨水薄塗＊，呈現平面的質感。

How

This piece stands out not by the sharp contrast of lights and shadows, but more by a clash of shapes and colors. I tried to make the staircase building ❶ "lean" against the perfectly ordered rows of windows in the background ❷ modifying the perspective to be more similar to a fisheye lens. I then tried to recreate all the details of the staircase correctly to enhance this contrast even further.

The car park sign ❸ had to stand out from all the greyness of this painting. I tried to make it as bright and saturated as I could and also to recreate the design true to reality. The look of the sign on the left side ❹ though did not please me as much. Something simple would look much better — just a shop selling used books and DVDs.

Lastly, I didn't want the trees to steal attention away from the buildings, so I filled their shapes with just flat and dark ink washes.

＊薄塗：用富含水分的筆上色的技法。

03 The mirror

Beyond the dark steps

鏡

昏暗樓梯的另一邊

地點

東京都千代田区內神田 3 丁目。從內神田中央通，
前往外堀通的捷徑。

Location

Uchikanda 3 chome, Chiyoda-ku, Tokyo. A short-
cut from Uchikanda Chuo Street through to
Sotobori Street

描繪了什麼？

　　高聳的建築物滿滿都是昏暗的樓梯❶和關
上的窗戶。我沿著兩棟樓之間陽光照射不太進
來的小路前進。在這條路的盡頭可以看到快速
下沉的夕陽❷和轉角餐廳的反光❸，形成美麗
的馬賽克。

What

I choose to take a back passage between tall buildings,
full of dark staircases ❶ and blind windows that
probably don't get much sunlight during the day.
At the alley's end, we meet a building reflecting the
light of the fast-fading evening ❷ and a brightly lit
up restaurant across the street ❸ — a magnificent
mosaic of colors.

如何繪製？

　　這幅畫的中心是如鏡子一般的大樓外牆，
畫起來非常具有挑戰性。我必須分開描繪每一
塊牆磚，才能呈現不同的光影反射❷。外牆的
下半部沒有畫線就直接上色，描繪泛著黃光的
餐廳❸。

How

The central, mirror-like wall was quite a challenge.
First, it required painting all the tiles separately,
one by one, changing colors on the way to represent
how each of them reflects light differently. ❷ What's
more, the reflection of the yellow shop ❸ had to be
recreated with no linework to help.

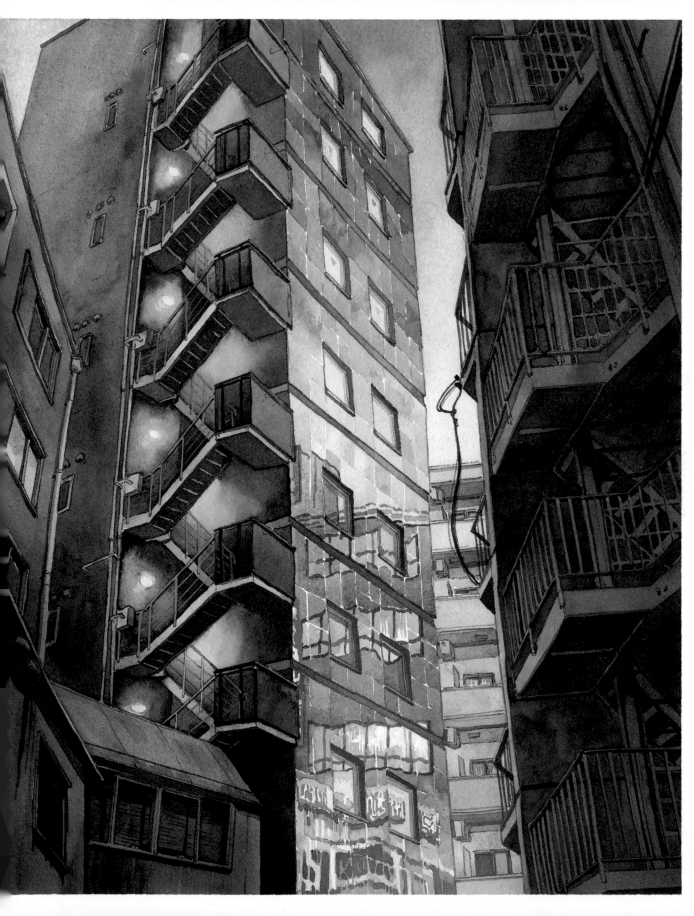

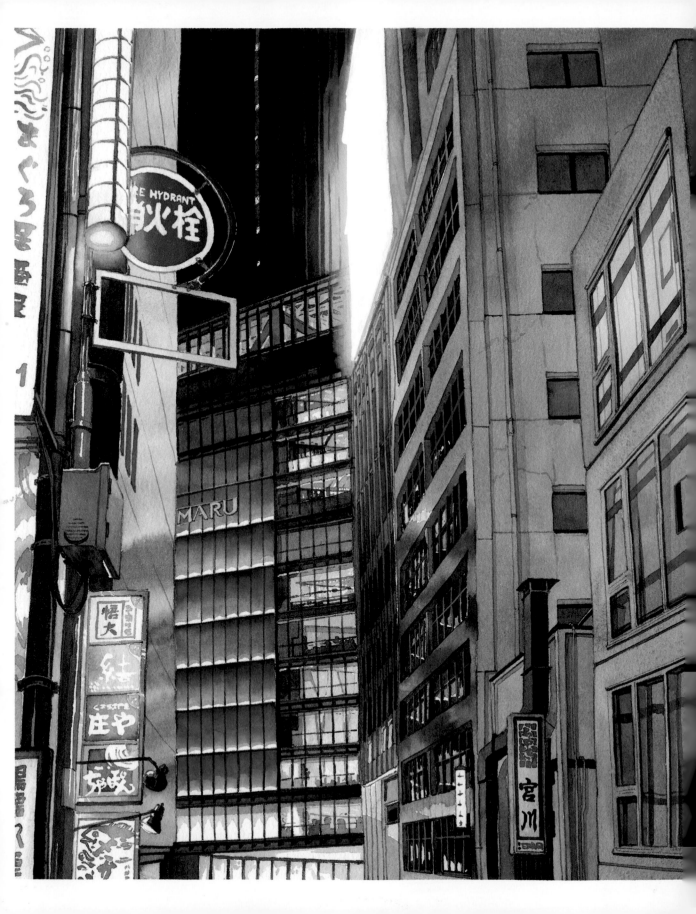

描繪了什麼？

右側大樓上方的發光看板 ❶ 非常刺眼，實際上看不清上面的內容。綠色和藍色的高彩度光線非常美麗，照亮周圍的建築物和窗戶 ❷。

What

The brilliant shop sign on the right-side building ❶ is actually too bright to be readable. It casts, however, a beautifully saturated green and blue light onto the surrounding structures' walls and windows. ❷

如何繪製？

這部分的多彩漸層 ❷ 畫起來非常愉悅。看板最明亮的地方維持白色 ❶，周圍發光的效果則是用強而有力的綠色表現。

為了增添這幅畫的真實感，我仔細描繪看板 ❸ 和後側商場每一層樓內部的樣子 ❹。

How

The colorful gradients ❷ were a pleasure to paint. I also tried to make the brightest sign ❶ as white as I could and to recreate the effect of it casting a powerful green light.
To add more realism to the picture though I had to precisely recreate all the signs ❸ and the insides of the shopping mall floors visible in the distance. ❹

地點

東京都中央区八重洲 1 丁目。從八重洲北口美食街的小路仰望大丸大樓。

Location

Yaesu 1 chome, Chuo-ku, Tokyo. Looking up Daimaru Building from an alley in an eatery area spread around the North Exit of Yaesu

為光影反射著迷
必須找到出路

Captivated by the reflection 04
We must find a way

05 2980
So many colors

七色光

2
9
8
0

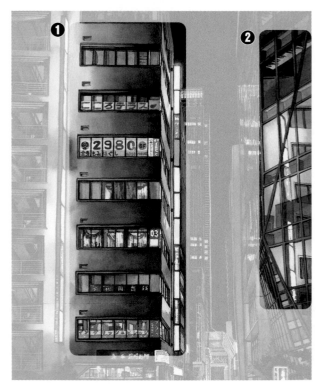

❶
❷

地點
東京都千代田区丸の内 1 丁目。站在八重洲口北側鐵鋼大樓前，隔著大馬路眺望美食街。

Location
Marunouchi 1 chome, Chiyoda-ku, Tokyo. Looking over the eateries area from the main street in front of the Tekko Building, north of Yaesu Exit

描繪了什麼？

每一個樓層都像在述說不同的故事❶。這種重複樣式立刻奪走了我的視線。

接下來，我發現右側出現些微的視錯覺。或許是因為建築物奇妙的角度，映在窗戶上的景色似乎與我想像的不同❷。

What

Each of the floors is telling an entirely different story. ❶ This repeating pattern catches my eye instantly. Then, I see that subtle optical illusion taking place here. Because of the angle at which the right building reflects the left one, it does not show what it seems. ❷

如何繪製？

由於每一層樓特殊的景象是成就這幅畫的主角，因此我盡量根據現實的樣貌描繪細節，努力重現內部的樣子和海報。另外，為了讓貼在窗戶上的廣告都能確實入畫，我也特別注意窗框的數量❶。

How

The uniqueness of each of the windows is what makes this illustration tick. I put a lot of effort to paint the building's insides and posters realistically and with as many details as I could. Counting the number of glass panes, so the letters correspond to the real signs included. ❶

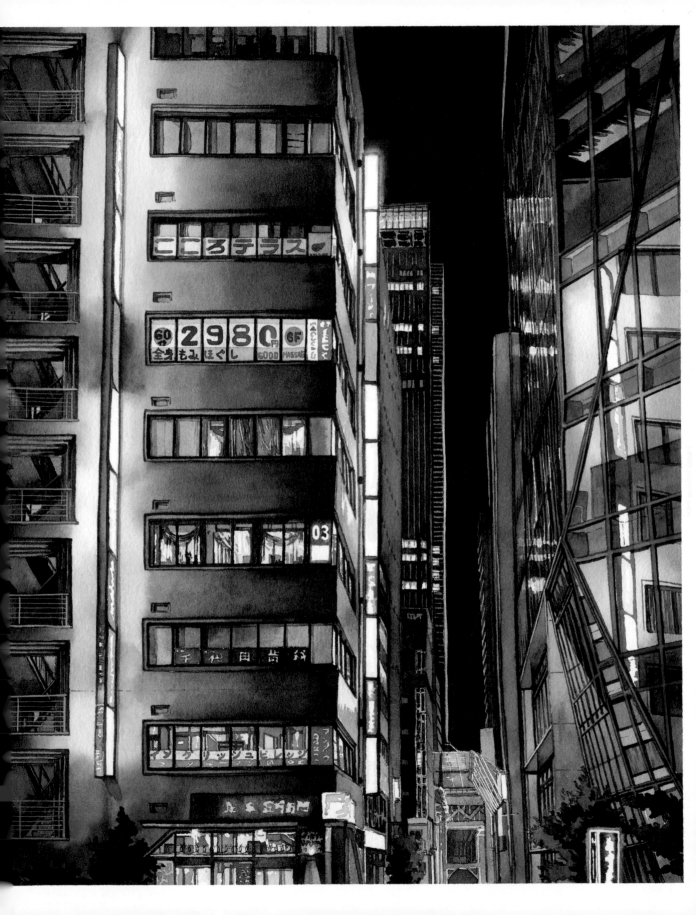

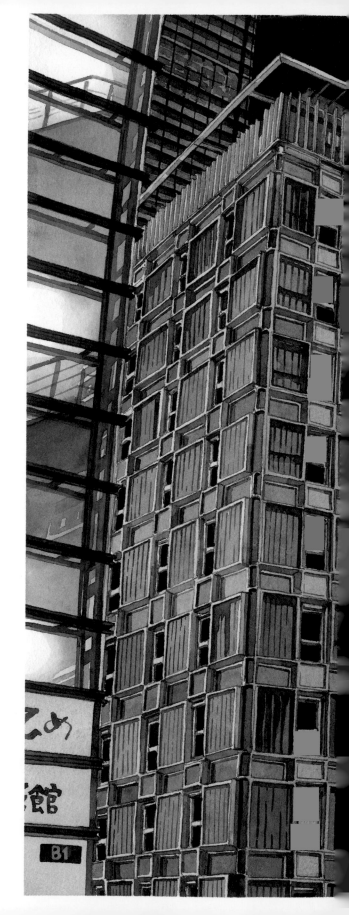

兩個月亮
被高牆圍繞

06 Two Moons

High walls of the garden

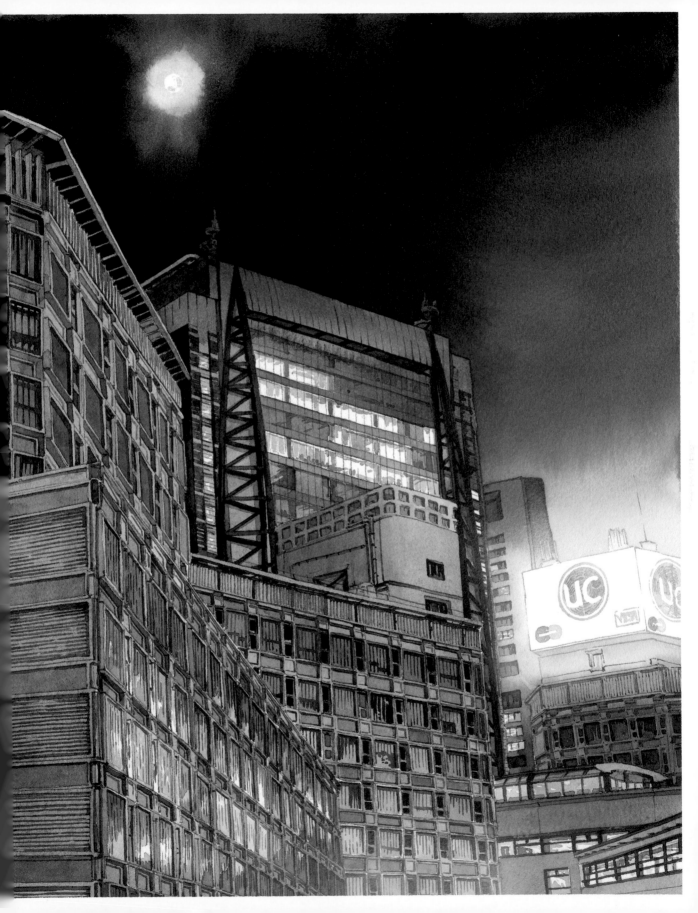

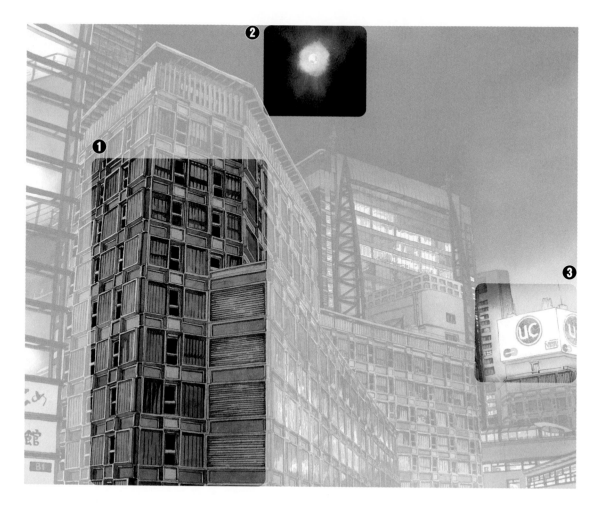

06 | 地點

東京都港区新橋 2 丁目。新橋車站銀座口。隔著新橋車站前大樓 1 號館仰望日本電視塔。

Location

Shimbashi 2 chome, Minato-ku, Tokyo. Ginza Exit of Shimbashi Station. Looking up at the Nittele Tower over the Shimbashi Station Building No.1

描繪了什麼？

當我一看到完全相同的「窗戶群」❶，立刻就被吸引，但也同時本能性地感到厭惡。就好像明知不健康卻還是忍不住想要剝掉結痂一般。主體的大樓放大了那些我喜歡和不喜歡的東京。冷漠和不斷複製的結構，讓我心生敬畏與不安。

另外，照亮景色的月光❷和點亮的銀行廣告燈❸，兩者的亮度和形狀相呼應，讓我想要提筆描繪。這個奇特的組合也讓我想起不在這座城市裡的某些存在。

What

The multitudes of identical windows on the main building ❶ pull me towards this scene and at the same time, disgust me on some more fundamental level. It's like a scab that you cannot help but to pick with unhealthy fascination. This structure is like an amplification of the aspect that I most love and hate about Tokyo — cold, repetitive structures that at once fill me with awe and unease.
I also wanted to feature the moon shining brightly on this scene ❷ and the lit-up bank commercial on the right side. ❸ These two, united by brightness and shape — an uncanny pair reminding us of the existence of the world outside the city.

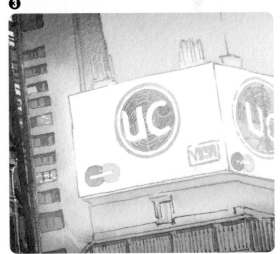

如何繪製？

描繪這幅畫的時候需要很大的耐心。

第一次看到這座大樓的時候，我甚至無法理解外牆複雜的結構 ❶。每一面都有些微的凹陷和凸起，創造出迷幻的氛圍、重複的紋理，以及難解的反光。

繪製其他作品的時候也相同，首先我會用鉛筆打草稿，確認想畫的東西是不是都能放進去？構圖是否成立？之後才加入許多細節。我尤其花費比平時更多的時間為這幅畫打草稿，注意每一扇窗和外牆的形狀是否完全契合。些許的失誤都有可能毀掉這個複雜的圖案。

How

This picture was an exercise in patience.

At first, I could not even comprehend the complicated structure making up all the walls of the main building. ❶ Each surface is either slightly depressed or sticks out a bit creating a genuinely psychedelic, repetitive texture and complex reflections.

In the initial sketching stage for each picture, I usually only roughly draw with my pencil, shapes of all the things I want to fit in the scene. To place them and see if the composition works before adding the final form and details with ink lines. Here, however, I decided to spend more time, carefully drawing each window and wall element. I had to be sure that everything meshes up perfectly — even a small mistake could break this complicated pattern.

奇妙的地方

Chapter 2

Strange places

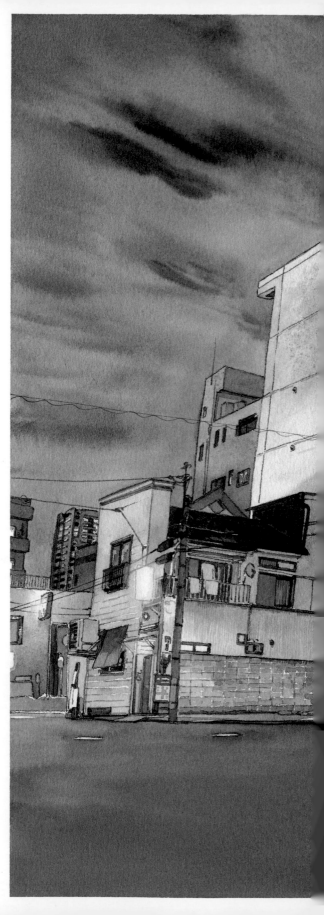

永無止盡的延續 流動

07 The flow
Continues beyond and above

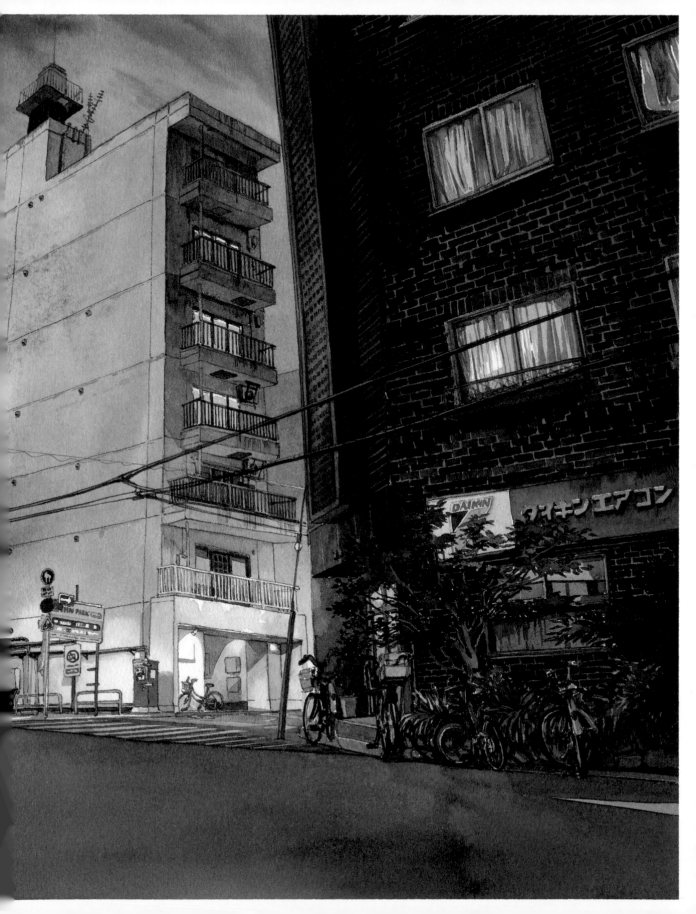

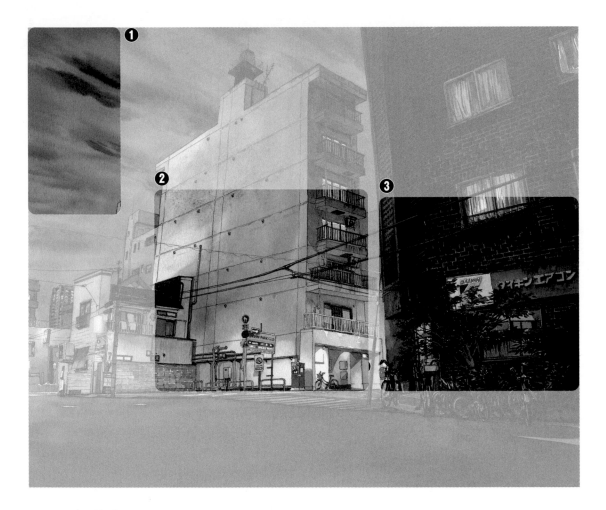

07 | 地點
東京都荒川区東日暮里５丁目。從日暮里車站往東延伸，日暮里中央通旁的小路。

Location

Higashi-nippori 5 chome, Arakawa-ku, Tokyo. On a side road off Nippori Chuo Street that stretches from Nippori Station towards east

描繪了什麼？

這個場景最初吸引我的是天空❶。街上的一縷光點亮薄雲，從雲的間隙中可以看到後面漆黑的天空。

獨特且美麗的雲朵流動❶，與前面這棟建築物絕妙契合。

接下來吸引我的是兩棟主要建築物（後面白色瘦長的建築物❷和前面有稜有角的陰暗建築物❸）奇妙的差異。

整個畫面的氛圍有些奇特，可以看見許多奇怪的角度和對比。為了找出最能呈現這種氛圍的構圖，我花了很長的時間尋找適當的拍攝角度。

What

The sky ❶ is the thing that attracts me to this scene — thin wisps lit by the glare of the city and only moments of the dark skies visible beyond.

The motion of the clouds, flowing in a very peculiar and beautiful way, ❶ is just the right match for the buildings in the foreground.

The other thing that draws my attention is the buildings themselves with their strange differences: thin and white one in the back, ❷ dark and blocky one imposing in front. ❸ The whole scene is a bit on the weird side, full of strange tension of uncanny angles and contrasts. I spend a long time here trying to find the most suitable point of view to recreating this atmosphere.

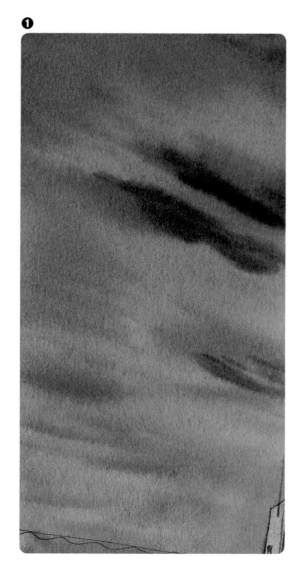

如何繪製？

　　最初的挑戰是畫天空 ❶。我不希望出現尖銳的
角度，因此先打濕畫紙，再讓畫紙乾一點，等待最適
合創造出模糊邊界但顏料又不會全部混合在一起的最
佳時機。

　　右側鋪滿磚的陰暗牆面 ❸ 是這一幅畫的獨特之
處。我知道為了讓磚牆在黑暗中也能看起來顯眼，必
須仔細描繪。最好的方式是一片一片地描繪，並在顏
色上做出些許變化。雖然這是非常漫長的工程，但也
因此繪出我心目中理想的紋理。

How

The first challenge was to paint the sky. ❶ I did not want
any sharp, hard edges here, so I wet the paper first, let it
dry a bit and started painting only when it was just right
to blur the paint strokes but keep the paint from mixing
entirely.

The full front of dark tiles ❸ on the right building was
something unique to this painting. Even though this was
a night scene, the tiles stood out enough that I wanted
to paint them properly. I knew from experience that it's
best to render them one-by-one introducing slight color
variations on the way. The whole process took quite a bit of
meticulous painting, but the resulting texture is very close
to what I had in mind.

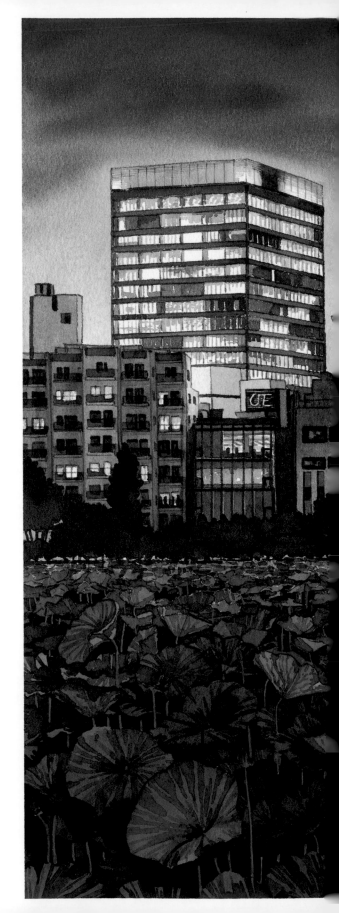

紫色大地

小心迷路

08 Violet fields

Don't get lost in it

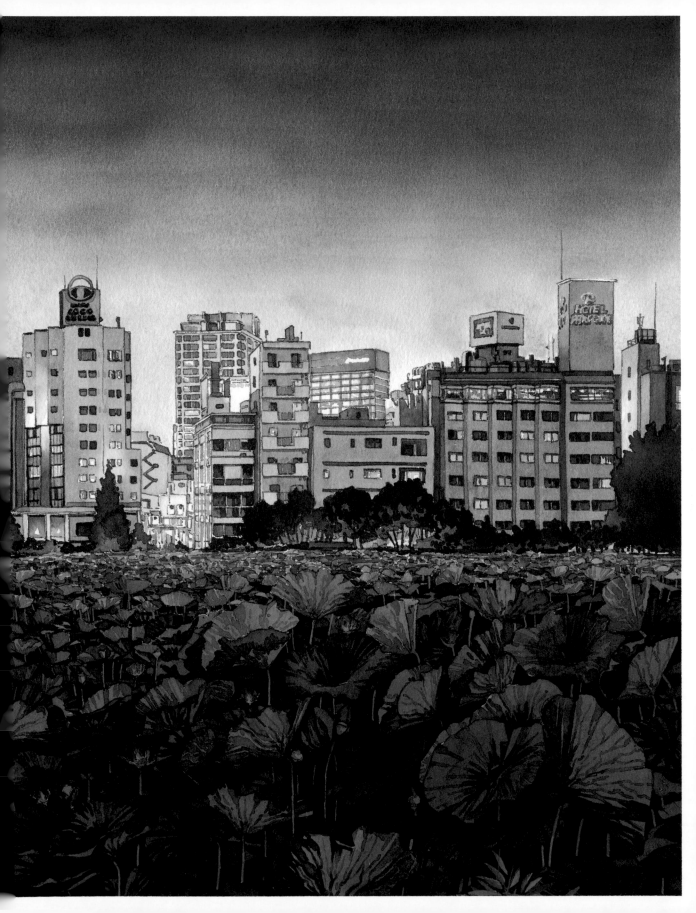

08 | 地點
東京都台東区上野公園 2 丁目。從弁天堂眺望上野公園不忍池盛開的蓮花。

Location

Ueno Park 2 chome, Taito-ku, Tokyo. From Bentendo, looking at a sea of lotuses covering the Shinobazu Pond

描繪了什麼？

當時我們正好外出取景，希望找一個有些奇妙又有點與眾不同的地點。穿過上野公園的時候，不可避免地誤入廣大的池塘和中間的小路。

首先，我為夜空的天際線感到驚艷。從這個距離可以在沒有任何遮蔽物的情況下看到大樓所創造出的市容❶，這在東京不是一件容易的事。這個角度尤其更是難能可貴。

我真切地想要描繪遠方這些高高低低的大樓，因為這座被蓮花覆蓋的池塘散發出我們一直在尋找的那種奇妙又讓人不安的氛圍❷。

What

During our location hunt walk, looking especially for places that seem a bit on the weird and unusual side we try to cross the Ueno Park. Inevitably, we stray onto the expansive pond and the path passing through its center.

At first, I'm surprised by the night skyline. Seeing buildings forming a cityscape ❶ from this distance, without anything obstructing the view is not something that often happens in the center of Tokyo. Not from this angle.

Looking at it, I feel I want to paint the uneven line of buildings sprawling in the distance. Even more, because the place oozes with the weird and unsettling atmosphere, we are looking for because of the whole pond filled with huge lotus plants. ❷

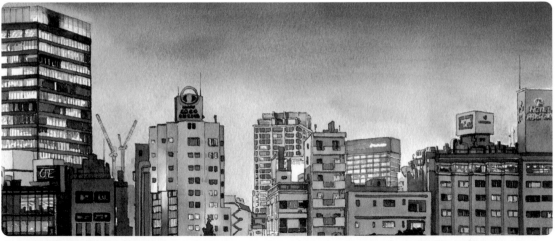

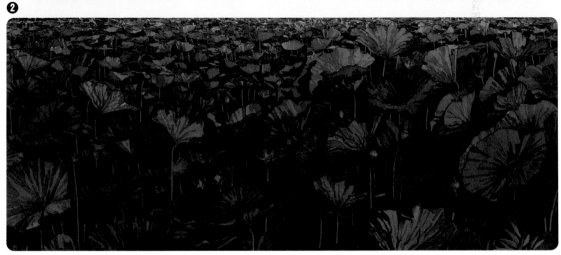

如何繪製？

很不巧地，我們取景的時候，這個地方的蓮葉已經枯萎沒有朝氣，實在不怎麼好看。我希望呈現的是華麗但又詭異的氛圍，因此著手調查蓮花盛開時應有的樣子。根據這些資料想像我希望呈現的氛圍，重現這個場景。

我花了很多時間畫荷葉。我不是藉由綠色到藍紫色的漸層方式，一口氣地描繪蓮花消失在深處的樣子，而是一片一片葉子仔細描繪，塗上不同的顏色。如此一來，每一片葉子都反射出不同角度的天空，看起來更自然。

How

We were a bit unfortunate that when we went for our location hunting the lotus plants were already withered with the enormous leaves brown and hanging limply. I wanted to make this scene more gorgeous-eerie than anything else, so first I had to do some research on how the plants look when they are beautiful and fresh. Based on this, I tried to recreate the mood that I had in mind.

Painting all of the lotus leaves took a lot of time. Instead of making one sweeping color gradient of the green disappearing into blue and violet in the distance and just adding some details on top, I first painted in all the leaves one by one, varying the color as I went. This approach made the plants look more natural, as each leaf reflects the colors a bit differently.

被
遺
忘
的
東
西

這是什麼感覺

09 The abandoned

What is this feeling

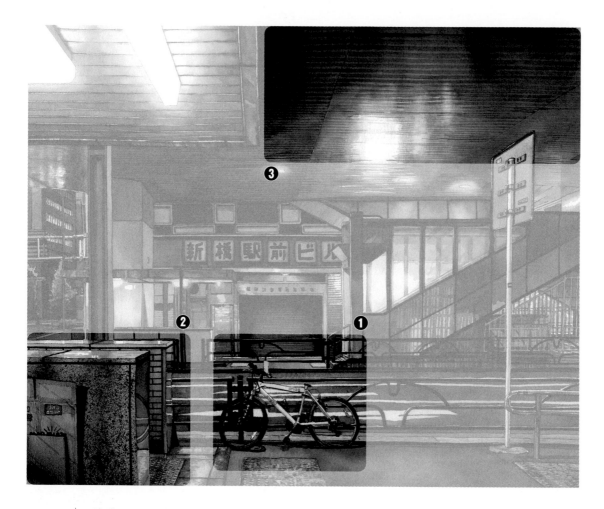

09 | 地點
東京都港区新橋２丁目。新橋車站汐留口。連接百合海鷗號的天橋下。

Location
Shimbashi 2 chome, Minato-ku, Tokyo. Shiodome Exit of Shimbashi Station. Under a pedestrian bridge that connects to Yurikamome

描繪了什麼？

這個景色的一切都讓我驚訝。被棄置的腳踏車連坐墊都沒有，看起來非常落寞❶。我按下快門，想著不知道這台腳踏車在這裡多久了？但我為了拍攝下一張照片，很快就離開了。

回家之後重新看照片，那裡的風景顏色鮮豔且充滿細節和紋理，奪走我的目光。

我很高興能夠把這個場景收錄到這本作品集裡。對我而言，這裡代表了那些我經常在東京看到有點詭異且陰森的地方。回想起陰暗的橋下道路、地下鐵的隧道、舊大樓的地下室和走道，甚至連那些地方獨特的氛圍和氣味也一起浮現在我的腦海裡。

What

This scene is a total surprise to me. I take the reference photo guided mostly by the abandoned bicycle ❶ looking very sad without its saddle. I wonder briefly for how long it is parked there and quickly walk on.

It was later when reviewing all the photos we took that night that this scene pulled me in with its richness of color, detail, and texture.

I'm happy that I managed to feature this scene in the book. A painting that, for me, represents all these weirdly spooky places so often found in Tokyo. Dark passages under bridges, metro tunnels, basements of old buildings or underground pedestrian passages. I can almost feel the specific atmosphere and the smell those places have just by thinking about them.

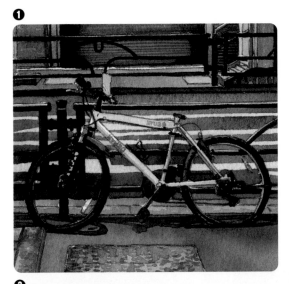

如何繪製？

　　這幅畫有許多複雜的質感，有趣但也非常難畫。

　　為了描繪地下鐵入口使用的大理石花紋外牆 ❷，我先在周圍貼上紙膠帶，再用暗紅色的顏料噴濺＊上色。使用這個技巧可以讓我很快地畫出具有特色的紋理，但其他的部分不使用相同技巧。尤其是這個金屬製的天花板 ❸，必須謹慎且精準地描繪。我先畫出漸層色，再重現光源反射的各種樣子，並特別留意表面的凹凸扭曲，畫出一條一條的線。

　　另外，我也特別用心在人行道上的黃色導盲磚和後方階梯的半透明玻璃等各種不同紋理。

How

The intricate textures add a lot of character to this scene but also make it challenging to paint.

To achieve the fake marble look of the metro entrance wall, ❷ I masked out this part with tape and decided to splatter on some dark paint. This trick allowed me to add some appealing texture very fast, but for other elements, like the metal roof, ❸ I had to be more deliberate and precise. I painted the smooth color transitions first, trying to recreate how the surface reflected various sources of light. Then I proceeded to paint the metal texture line by line, changing the color on the way to make it match the underlying gradient.

I also paid close attention to other surfaces, like the yellow pedestrian guides or half-transparent glass of the background staircase.

＊噴濺：手指彈畫筆讓顏料噴濺的上色技法。

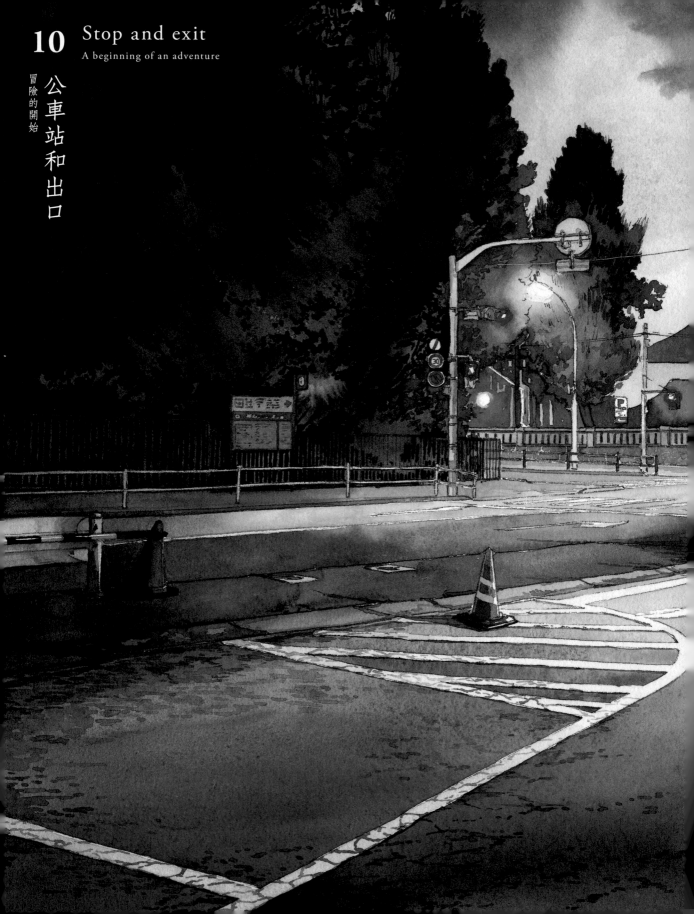

10 Stop and exit
A beginning of an adventure

公車站和出口

冒險的開始

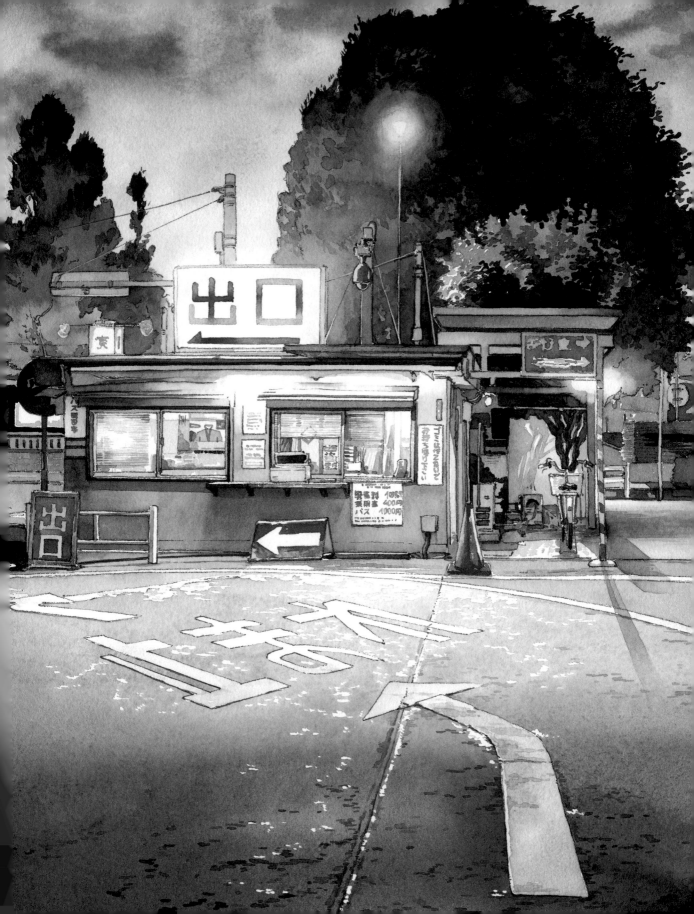

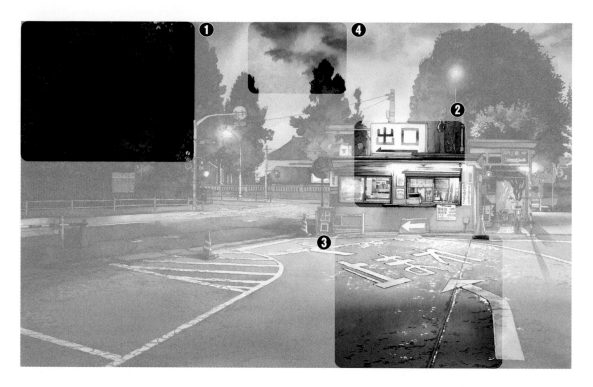

10 | 地點
東京都台東区上野公園 7 丁目。從上野公園通上的
大型停車場內側望出去。

Location
Ueno Park 7 chome, Taito-ku, Tokyo. A view from a large car park
along Ueno Park Street

描繪了什麼？

　　與這部作品集收錄的其他許多畫作相同，我們是
在偶然的情況下看到這個景色，完全出乎預料。想必
是我們在夜晚進行東京探險的成果。我們原本打算抄
近路前往下一個目的地，結果走到了一個幾乎沒有車
子的停車場。

　　穿過一片漆黑的無人觀光巴士後看到這番景色，
直覺感受這裡是符合《東京夜行》主題的場景。

　　我為了掌握這個景色的所有元素，因此拍了許多
照片。人的眼睛真是一個奇妙的東西，可以同時看見
樹木黑暗的影子❶和逆光刺眼的看板文字❷。我調
整相機的各種設定，捕捉這個場景的所有一切，需要
經過「統整」才能繪成一幅畫。

　　我在繪製的時候，希望重現記憶中的情感和景色
的氛圍。黑暗的樹影和與之對比的明亮看板，以及暗
夜裡有點詭異又有點令人害怕的空蕩停車場。

What

Like many of the illustrations in this book, this view is a
complete accident and a surprise for me. A result of our
exploration of night Tokyo. We are just randomly walking,
trying a shortcut through an almost empty parking lot to
get to next point on our map.

Walking from behind an empty and dark tourist bus, I see
this scene, and at once I know it's perfect for this project.

I take many reference photos here trying to capture all the
elements of the view. Human's eyes are excellent — they
can see all the dark parts in the trees ❶ and the text on
the brightly backlit signs ❷ at once. With a camera, I have
to take many photos at different settings to capture it all to
then "stitch together" as one image.

While painting, I tried to recreate the feeling and
atmosphere of the scene as I remembered it. The signs,
bright against dark silhouettes of the trees. The empty
parking lot, a bit eerie and scary in the night.

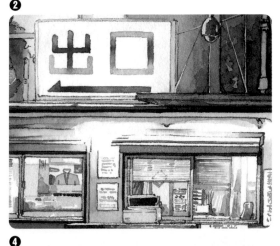

如何繪製？

　　關於這幅畫，我在許多意想不到的地方遇到了難題。例如漆黑柏油路上的白色文字和圖案❸，必須很有耐心地用留白膠處理。

　　另外，茂盛的樹叢❶也是讓我停筆思考的部分。混合多色顏料薄塗畫出的形狀非常漂亮，但還需要加強葉子的影子等深色細節。在此，與其加入更多顏料，我選擇畫線稿時也會使用的「蒼墨」墨水。

　　這幅畫使用的紙張不適合用水彩疊色，深色墨水更能表現我心目中深色且均勻的影子。

　　另外，這幅畫也是「意外驚喜」的例子之一，使用傳統手繪和顏料的時候，有時會發生這樣的意外。我從天空開始著色❹，但卻失敗，我一點也不喜歡畫出來的樣子。我感到沮喪，用浸濕的筆和衛生紙擦掉上面的顏料準備重畫，沒想到卻出現驚人的效果，於是決定將其保留下來。

How

This painting gave me some problems in unexpected places. I thought that the white letters and patterns on the dark asphalt ❸ would be difficult, but with some patient masking fluid usage, I got them right with no complications.

The dark trees ❶ were the part where I stopped to think. The initial watercolor wash I painted by mixing many colors looked pretty but required darker details. Instead of just using more watercolors, I tried the Sou-Boku ink.

I knew that the paper I was using here was not so great for layering watercolor paint and hoped that the ink would give me the dark, uniform shadows I wanted.

This painting is also an example of so-called "lucky accidents" that sometimes happen when working with traditional media. I painted the sky first, ❹ and it was a failure. I did not like the look at all. Dispirited, I lifted the paint with wet brush and tissue paper planning to repaint the sky, and saw, to my astonishment that it looked great. I left it as it was.

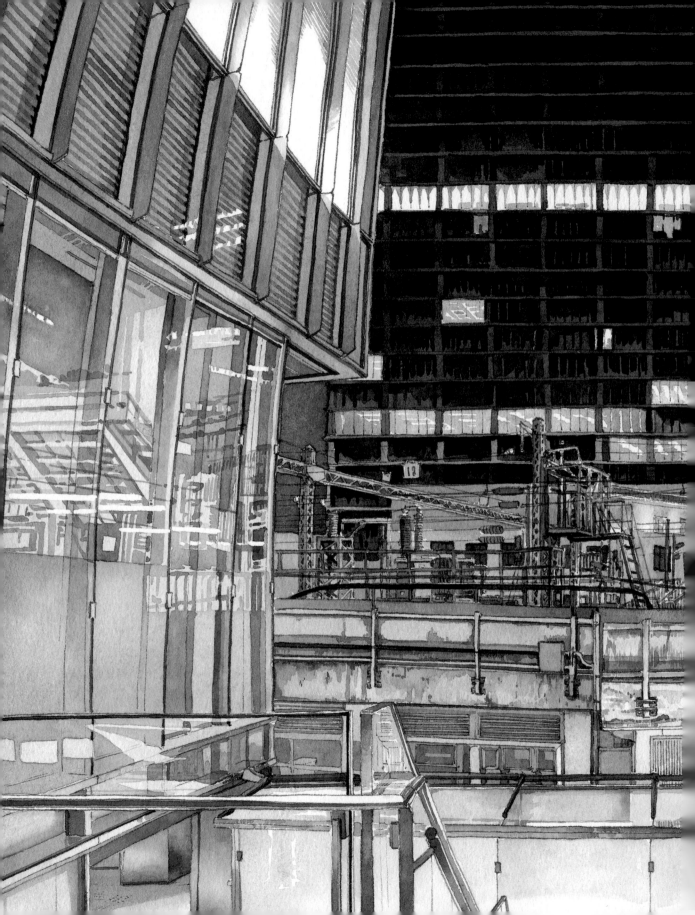

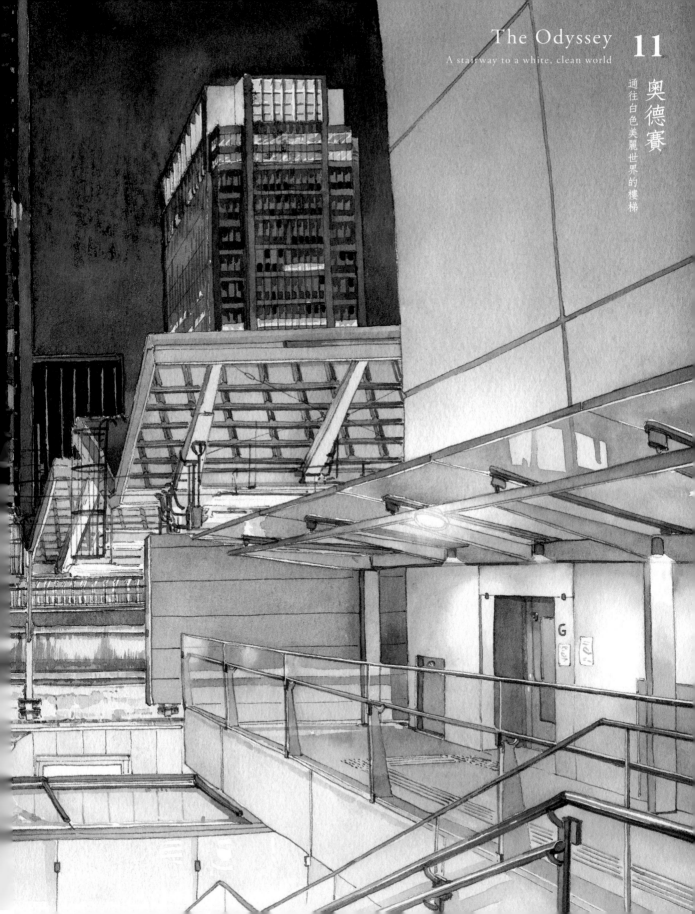

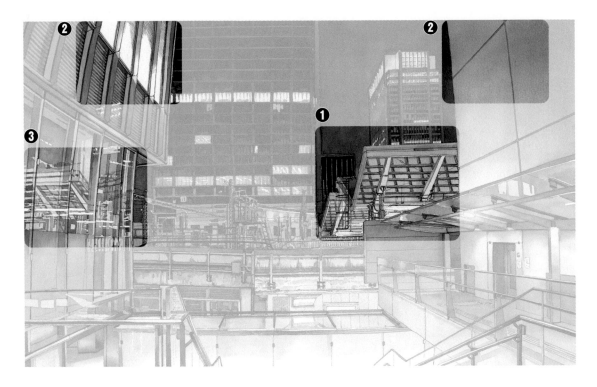

<table>
<tr><td>

11

</td><td>

地點

東京都千代田区丸の内 1 丁目。從GRANDROOF
平台南側樓梯回頭看新幹線的高架。

</td><td>

Location

Marunouchi 1 chome, Chiyoda-ku, Tokyo. Looking at the elevated
Shinkansen train tracks from the stairs of the GRANROOF Building
deck

</td></tr>
</table>

描繪了什麼？

　　白色光線壟罩的樓梯造型簡單，帶有工業風格，
散發出空虛又詭異的氛圍。一看到這座連接兩棟辦公
大樓的樓梯，我立刻決定前往一探究竟，看看這個樓
梯究竟延伸到何處。

　　只走了幾階，就感覺自己好像置身於完全不同的
世界裡。從可以聽到東京車站人車喧囂的漆黑道路，
進入有如科幻電影一般的場景。這裡看起來就像是白
色且空無一人的太空站。

　　爬上樓梯之後又是全新的驚喜。被燈光照亮的
東京車站月台❶、電車送電線的叢林、高聳的辦公大
樓，以及消失在遠方又冷又黑的夜空。

　　當我看到這個被光亮的牆壁和樓梯包圍的黑暗
空間，就立刻決定要納入我的這部作品集裡。

What

A staircase bathed in white light, empty, and a bit on the
eerie side of simple industrial design is inviting us. The
moment I see these stairs connecting two office buildings, I
know I have to check where they lead.

Only a few steps on, and I already feel like I'm in a
completely different story altogether. Gone are the dark and
loud streets surrounding Tokyo Station, bustling with cars
and full of people. We are moving to a place that smells
strongly of science fiction movies — the ones set in white,
empty corridors of space stations.

And beyond the staircase — another surprise — lit up
Tokyo Station platform, ❶ a jungle of train power lines,
tall office buildings, and the cold, black emptiness of skies
disappearing into the distance.

As I see the dark background surrounded by white
buildings and the brightly lit staircase, I know that I have to
feature this scene in the book.

❶

❷

❷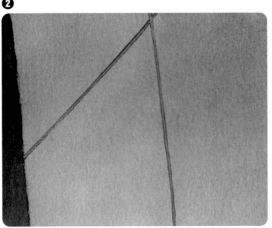

❸

如何繪製？

　　對於我而言，這幅畫的焦點非常重要。我想要呈現在有如太空站般乾淨潔白的大樓圍繞下，眺望遠方黑暗宇宙的獨特氛圍。

　　為此，我特別注意後方沉入暗夜中的大樓與前方大樓的對比，用明亮的色彩描繪前景。另外，為了讓看畫的人將視線集中在畫的中心，於是刻意扭曲前景大樓的形狀，營造魚眼的效果 **❷**。我無論畫什麼都不會用尺，因此更能盡情地運用直線和透視法。

　　另一個挑戰是讓明亮的月台反射到左側大樓的玻璃上 **❸**。在處理這種沒有線稿的部分時，必須花費很長的時間，從亮到暗，慢慢地仔細描繪。完成之後，作品看起來更寫實。

How

The point of focus was essential to me in this picture. I wanted to recreate this feeling of being surrounded by the clean, white space station-like buildings while looking out on the black expanse of night beyond.

To achieve this, I had to be careful to paint the foreground using bright colors to contrast it with the dark buildings in the distance.

I also tried to use a fisheye lens effect to guide the viewer's eyes to the center of the picture. I bent and deformed the shapes of the foreground buildings **❷** to archive this. I draw all scenes without the use of a ruler, so it's easier to play with lines and perspective.

The other challenging part that I knew I had to get right for this piece to work was the reflection of the bright station platform in the left building's glass side. **❸** Things like this — contents with no pen lines are always time-consuming and have to be painted very carefully, step by step from the lightest to darkest tones. If done right, however, they can add a lot of realism to the picture.

12 No one here

But everyone inside

沒有人的地方

但所有人都在裡面

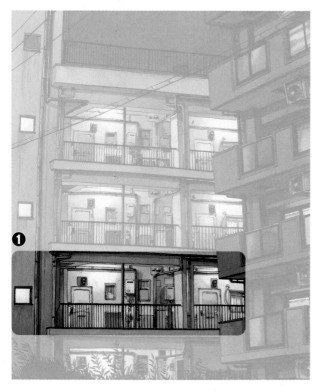

地點

東京都荒川区東日暮里5丁目。連接鶯谷車站和三河島車站的尾竹橋通附近。其一。

Location

Higashi-nippori 5 chome, Arakawa-ku, Tokyo. Near Otake-bridge Street that connects Uguisudani Station and Mikawashima Station, No. 1

描繪了什麼？

這個被燈光點亮卻又空虛的空間吸引了我。有些詭異和害怕，但同時又有種似曾相似的奇妙感覺，好像曾經來過或看過這個場景。這裡是各種不同故事的入口。

What

Brightly lit but empty spaces like this are something that fascinates me. They can be a little eerie and scary, but at the same time, they give off this weird nostalgic feeling. It's like you know this view, been there before — a portal to many different stories.

如何繪製？

我想要描繪這個場景，但無論怎麼取景都很難符合這本書的比例。我絞盡腦汁，決定以兩棟建築物為主角，整幅畫就只畫這兩棟建築物。為此，我決定讓後面的建築物比實際多加一個樓層❶。

How

I wanted to paint this scene, but it would not fit easily into any of the illustration formats of this book. In the end, I decided to focus only on the two apartment blocks and fill the whole painting just with them. To do this, I added one more floor to the back building. ❶

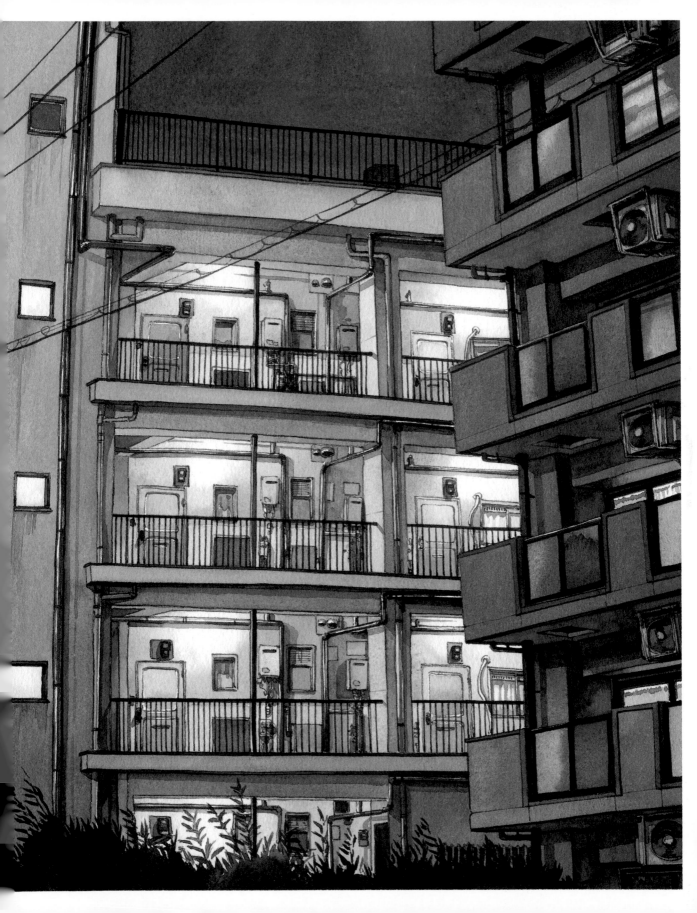

橋與電車

Chapter 3

Trains and bridges

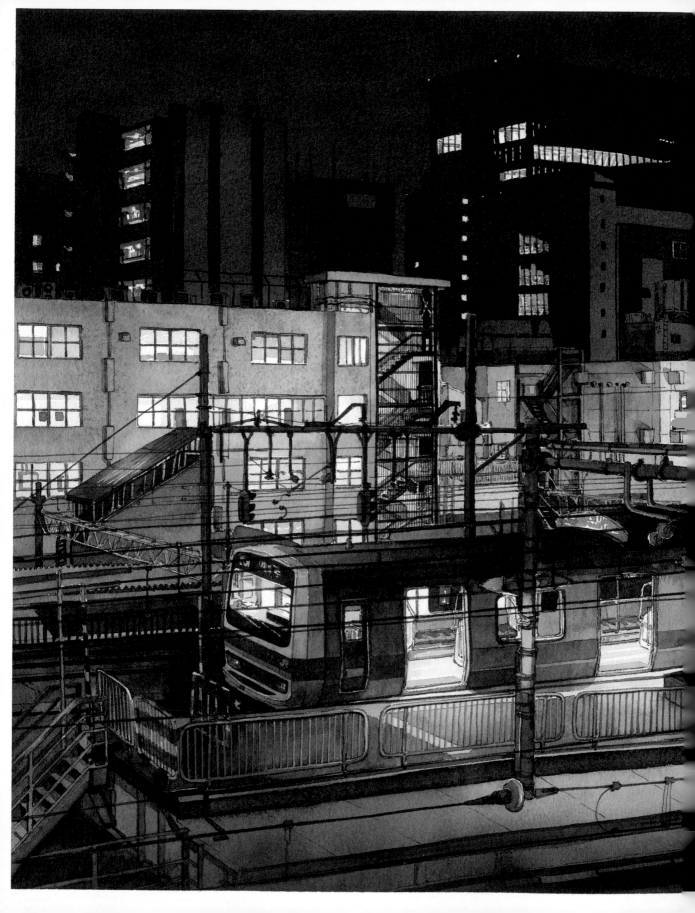

軌道的終點
電車正在等你回家

End of the line　13
The train waits to take you back

13

地點
東京都台東区上野 7 丁目。從都道 452 號上的兩大師橋往下看JR電車軌道。

Location

Ueno 7 chome, Taito-ku, Tokyo. Looking down on a JR railroad from Ryodaishi Bridge over the Metropolitan Road Route 452

描繪了什麼？

寂靜與不動的電車❶。車門敞開，電車在無人月台發光的樣子深深吸引了我。很幸運地，這台回送列車剛好停在這裡。我思考著應該從什麼角度呈現這個場景，也拍了許多照片。我知道我想要描繪空無一人的電車座椅，但其他的部分又該畫什麼呢？

我嘗試了許多不同的構圖，最後確定前後兩層的建築物群（背景陷入黑暗之中的大樓和前方被月台照亮的大樓）所帶來的強烈對比和界線❷，最適合呈現距離感和整體的氛圍，也最符合我追求的效果。

What

The silent, stationary train, ❶ with its doors wide open, spilling light on the empty platform is what stops me in my tracks. We are lucky that the train simply stays there, out of service — we can take many photos from different angles and decide how to paint it later. I know that I would like to feature the empty seat rows, but what about the rest of the picture?

I tried a lot of composition ideas, but finally, the sharp contrast line ❷ between the dark buildings in the background and the ones lit by the bright station platform lights was what worked perfectly for recreating the feeling of the distance and the atmosphere of this place.

❶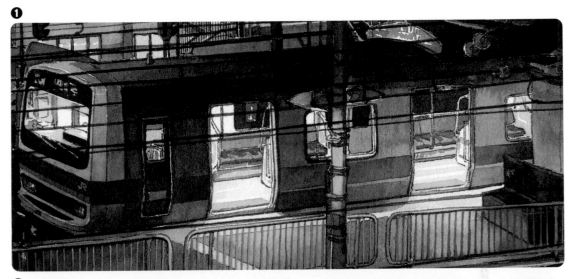

❷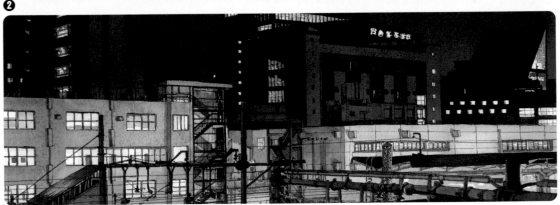

如何繪製?

　　這幅畫是實驗性的作品(本書有很多水彩畫的「第一次」,這幅畫尤其特殊)。在我塗完底色之後,我發現背景漆黑大樓的紋理太過顯眼且複雜 **❷**,無法展現上述前後兩層建築物群的對比。

　　為此,我用紙膠帶遮住包含前面建築物在內的畫紙,混合暗紅色和鮮艷藍色的顏料,再用噴槍為上半部上色。因為有了這道手續,背景的建築物變得更暗且顏色均勻,更能強調出與前面建築物的界線。

　　雖然這個如魔術般的神奇技巧不是到處適用,但這次剛好是嘗試這個方法的機會。

How

This picture ended up being a bit of an experiment. Yes, this series of paintings had a lot of watercolor "firsts" for me, but this piece was something special. After I finished laying down the base colors, I noticed that the dark background part was too textured and not dark enough to show the contrast I mentioned earlier. I needed this strong line! **❷**

I covered the bottom part of the painting (including the bright buildings) with paper and masking tape and went over the dark section with few airbrush passes of dull red and intensive Indigo blue mix to make it more uniform and darker at the same time.

This isn't a magic trick technique I can use anywhere, but I'm glad it worked here.

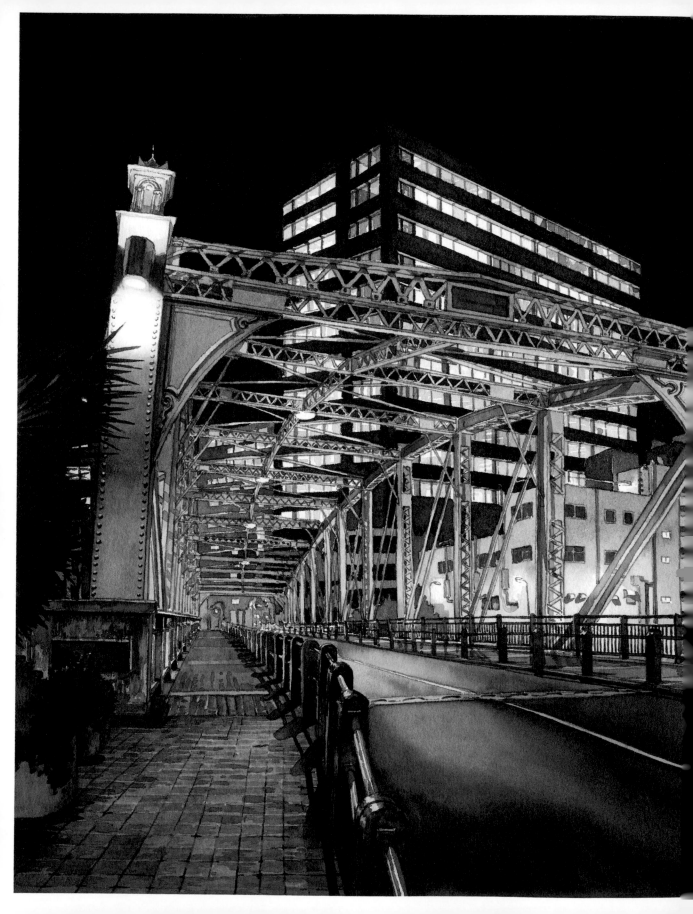

變幻無常的永恆
沒來過的地方

Too fragile to fall 14
How come we never went

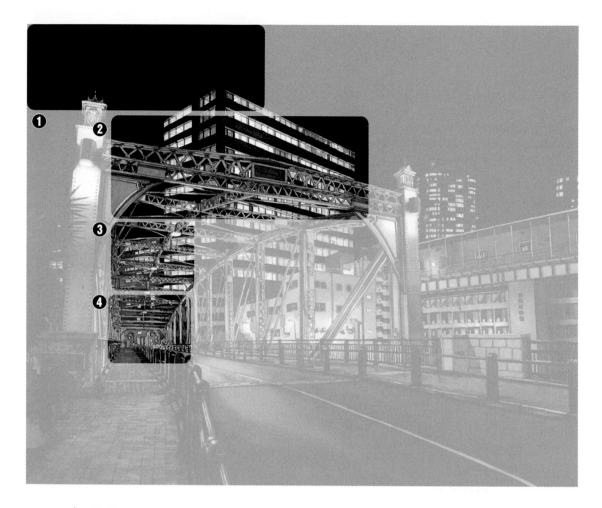

14 | 地點
東京都中央区湊 1 丁目。從西側眺望通往靈巖島的南高橋。

Location

Minato 1 chome, Chuo-ku, Tokyo. Looking at Minamitaka Bridge to Reiganjima from the western side of the bridge

描繪了什麼？

我們外出尋找東京具有魅力的橋，這裡的風景給我的印象最深刻。內側的暖色燈光照亮金屬結構的橋，看起來就好像浮在水面上一般輕盈且細緻。

我為了作畫而拍照，想像過橋前往對岸的人，試著尋找符合他們視線的透視效果。我同時也在尋找能夠與這座由開闊鐵架和厚實鐵塊所構成的橋形成對比的東西。夜空中聳立的辦公大樓和堅固的水閘門外牆，正符合我的需求。

What

On our night location hunting walk to see some of Tokyo's more interesting bridges, this is the one that probably makes the biggest impression on me. The metal structure lit up with warm-colored lights from inside appears incredibly airy, fragile, and light enough to float above the water's surface.

Taking reference photos to use later, I try to search for a composition that would show the bridge from the perspective of a person just about to walk through it to the other side. At the same time, I look for something more substantial to contrast with the openwork frame of the bridge. The dark office building towering in the distance and the watergate creating a solid wall on the right seems perfect for this.

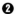

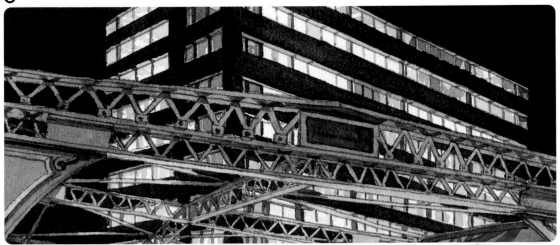

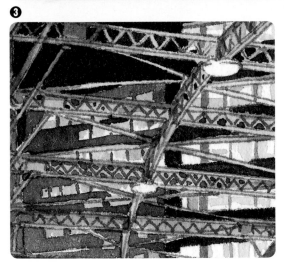

如何繪製？

為了凸顯橋的細緻框架和辦公大樓發亮的窗戶，於是我決定將天空塗黑 ❶。

橋的構造非常難畫，是一大難題。細緻精巧的形狀是這座橋趣味之所在，但打草稿和用墨水畫線稿的工作卻是非常棘手。越是遠處，線條和上色必須越簡單。我用鋼筆勾勒橋前段的所有線條 ❷，中段只勾勒部分線條 ❸，越往後線條越少、越簡化 ❹。

How

I tried to make the sky ❶ in this picture especially dark, to make the delicate frame of the bridge more visible and to also expose even further the bright windows of the back office building.

The bridge structure itself was a bit problematic. The very reason why it's attractive — the thin, light, and complex mesh of elements had to be carefully sketched and then traced with ink. The further in the distance the bridge continues, the simpler the drawing and colors had to be. At first, I was able to trace all the edges of the bridge's metal structure with my fountain pen. ❷ At half the distance, I just drew some of the lines, ❸ but far in the background, the shapes had to be simplified even further. ❹

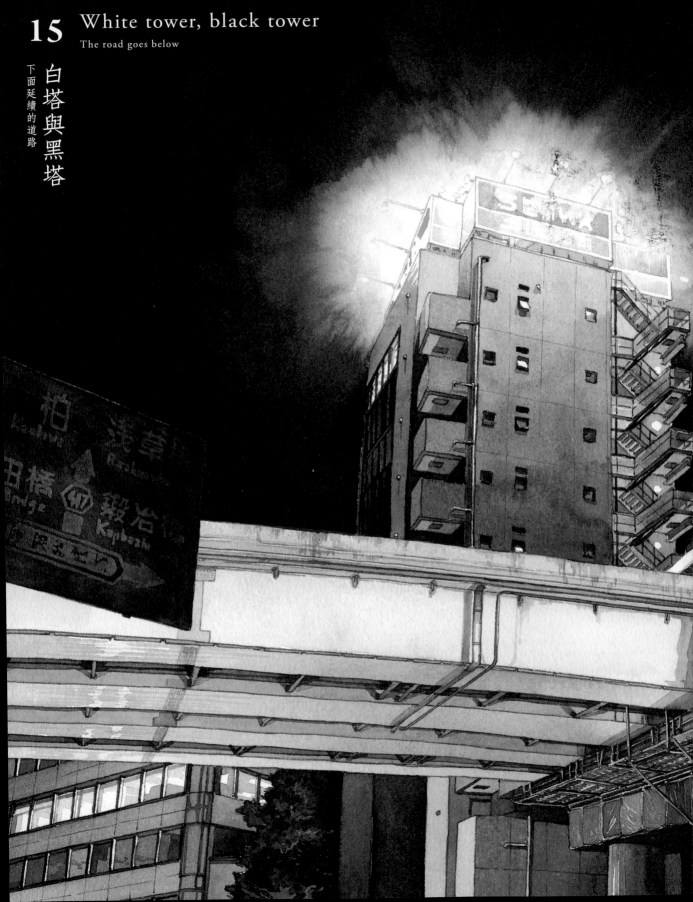

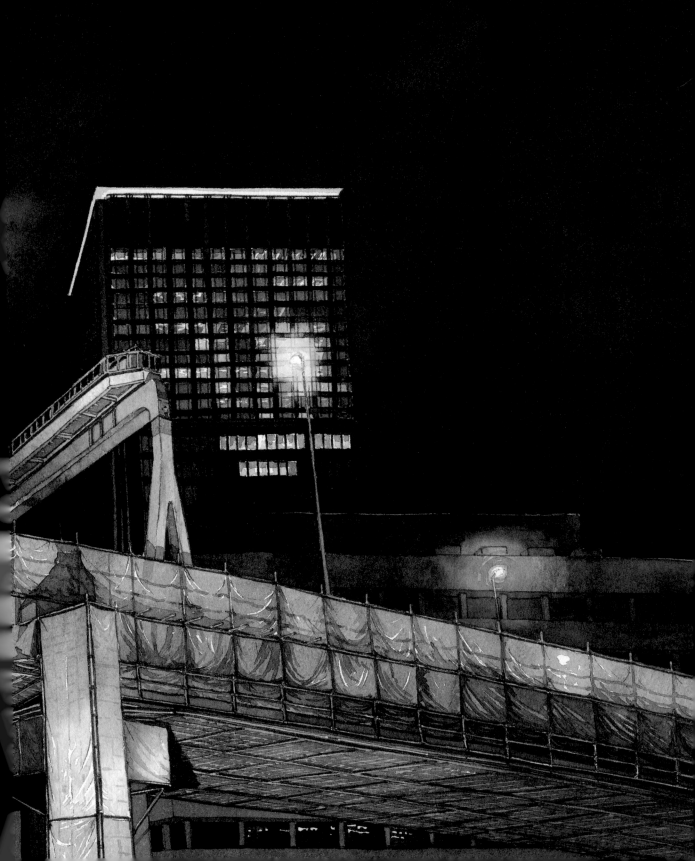

15 | 地點
東京都千代田区大手町２丁目。從沿著江戶通的新幹線高架下，仰望新常盤橋上的高速公路。

Location

Otemachi 2 chome, Chiyoda-ku, Tokyo. Looking up at a highway on Shin-Tokiwa Bridge from below an elevated Shinkansen railroad along Edo Street

描繪了什麼？

聳立夜空的兩棟大樓，好像成對的城堡一般。

一棟大樓有陽台和外露的樓梯，外觀複雜。散發的銀色亮光與漆黑的夜空形成強烈對比❶。點燈的巨幅廣告刺眼，甚至無法辨識上面的文字。

另一棟大樓則是簡潔劃一的玻璃和金屬。輪廓融入背景之中❷，凸顯光的線條和並排的窗戶。

這兩棟建築物抓住了我的目光，我決定讓它們成為這個場景的主角。建築物好像長在前方彎曲的高速公路上一般，這個景象深深吸引了我。

然而，當我開始描繪高速公路因維修工程所覆蓋的塑膠布❸時，我直覺認為這些塑膠布奪走了主角的寶座。如同這幅作品，有些時候，出乎意料的地方卻成為畫作的焦點，就連身為作者的我也沒有想到。

What

The two buildings in the back, imposing like two castles.
One, of complicated shape with balconies and staircases, white, contrasting sharply with the black sky, ❶ lit up to the point that it's hard to read the large signs.
The other one dark, a simple and efficient block of glass and metal that melts with the background, ❷ nothing more than a bright line and rows of window lights floating on the night sky.
I think that these two buildings will be the main elements in this scene — they were the thing that caught my eye in the first place. How they seem to grow out of the curving highway in the front is mesmerizing to me.
But later, when I started painting the temporary fabric that protects the street below from the renovation going on the elevated highway, ❸ I knew at once that it stole the show away. It sometimes happens that a part of a painting is a complete surprise to me in such a way.

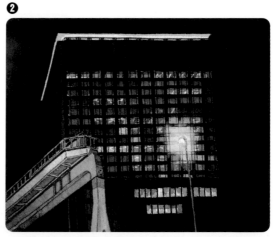

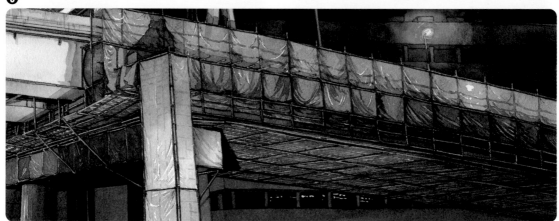

如何繪製？

　　這幅畫是充分發揮耐水性墨水威力的作品之一。與水彩不同，有顏色的墨水經過稀釋後，色調經常會改變。這一點在需要畫出精準的顏色時非常讓人頭痛，但這幅作品我決定試著利用這樣的特性。

　　首先我把天空明亮閃耀的範圍 ❶ 沾濕，再從邊緣讓墨水慢慢滲透。如此一來不僅顏色會從明到暗，也能營造從綠到藍紫色不同色調的漸層效果。至於剩下的天空，為了與前方明亮的道路對比，我使用深色墨水，以薄塗的手法畫出均勻且平面的暗夜。

　　塑膠布畫起來有些費工。不僅必須呈現因為受到右後方街燈的照射而呈現半透明狀，還要留下白色的反光，並藉由影子描繪出塑膠布有些下垂的樣子。

How

This painting is also one of these cases in which the waterproof ink shines so well. Differently to watercolors, colored inks sometimes change their hue when diluted. This can be really bothersome when trying to paint accurate colors, but in this illustration, I decided to use this property to my advantage.

I covered the sky around the brightly light ❶ area with water first and then slowly added ink to the edges. This way, I was able to create a gradient of color that not only goes from light to dark but has some different hues of green and violet during the transition. I then covered the rest of the sky thickly with ink to create an almost uniform, flat dark wash contrasting with the bright street in front.

The protective fabric in the foreground was a bit tricky to paint. I had to be careful to represent the shape of the slightly sagging fabric by leaving white highlights and adding shadows while trying to make it look like it was half transparent — backlit by the streetlights behind it.

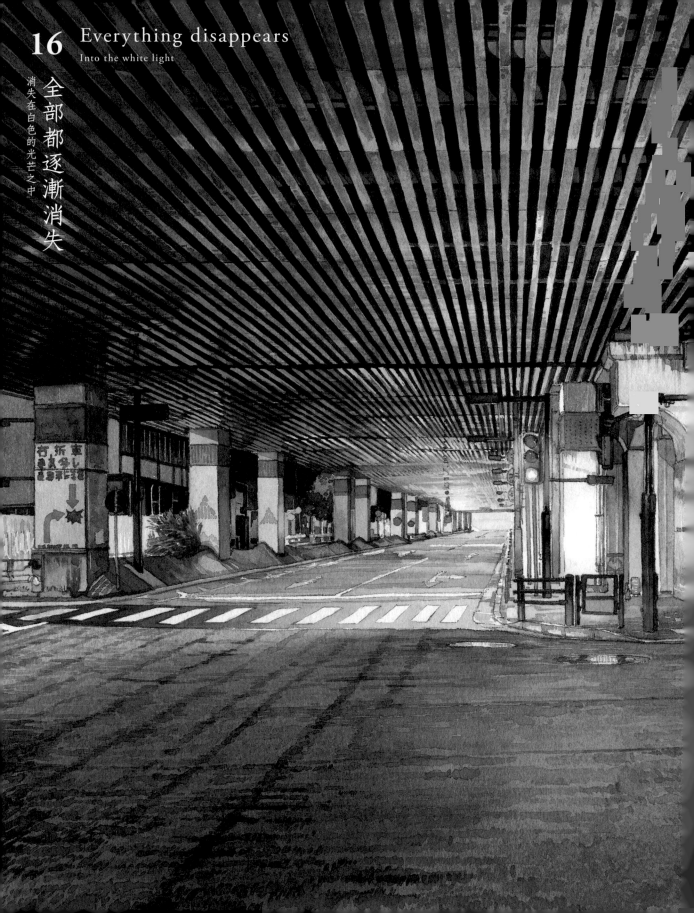

16 Everything disappears
Into the white light

全部都逐漸消失
消失在白色的光芒之中

16 | 地點
東京都千代田区大手町２丁目。新幹線的高架橋與一般鐵路線的常盤橋鐵路橋並排的地方。

Location

Otemachi 2 chome, Chiyoda-ku, Tokyo. At a place where an elevated railroad for Shinkansen and Tokiwa-bashi Bridge with old railways stretch side by side

描繪了什麼？

我們一邊聽著頭上新幹線通過的聲音和偶爾從右上綠色高架橋通過的電車聲音，一邊散步。

這裡就像地下世界，除了我們之外的一切都靜止不動。這裡除了交通號誌之外，沒有任何變化的空間。

沒有天空的平坦世界延伸向遠方，我被這裡的景色深深吸引。

金屬製的新幹線高架橋底部❶，因燈光而散發特有的光芒。結合右上鐵路橋複雜的構造❷與節奏重複的斑馬線❸，創造出獨特、近乎催眠式的驚人圖案。

畫中，幾乎所有線條都集中到遠方的一個點，主導整個畫面。這次有機會在沒有大型遮蔽物的場景，使用一點透視法繪製。我從來沒有在夜景圖中使用這麼大膽的手法，尤其規模又是如此龐大。

What

We are walking under a Shinkansen line while listening to the sound of the super-express trains passing overhead, accompanied by the occasional slower one on the tracks and bridges to our right.

Here, in this underground-like world, nothing moves, except for us. Nothing changes but the colors of the traffic lights.

I'm fascinated by this vision of a compressed, flat world without a sky, stretching endlessly into the distance.

The metal underside of the train line reflects the glare of the street lights in a very peculiar, beautiful way. ❶ Combined with the complex structure of the bridge ❷ and the repeating rhythm it the zebra crossings, ❸ the whole scene is overwhelmed by a unique, almost hypnotizing pattern.

Almost all the lines in this picture converge in the distance, dominating the scene. This pattern presents a unique opportunity for a huge, unobstructed exercise in a one-point perspective composition — something that I was not able to do in my night illustrations yet. Not on such a big scale anyway.

如何繪製？

　　我發現僅用水彩很難描繪出金屬越遠越小的細緻模樣❶。然而，在使用白色顏料增添質感之前，我希望盡可能地呈現金屬感和反射出周圍的樣子。

　　首先我用多彩漸層描繪光的反射和金屬元素。之後添加一些紋理細節，並在左上高架橋的底部畫上暗色的溝槽。接著混合白色的廣告顏料和水彩顏料，為少部分需要的地方打亮。

　　我把為道路表面塗色的工作留到最後，因為我知道添加恰到好處的細節是表現距離感的關鍵。我清楚描繪前景所有物體的紋理❹，但隨著道路往後推進則慢慢減少，讓畫面看起來更像遠方。

How

I knew that the delicate pattern on the left side of the painting, getting smaller and smaller in the distance ❶ would be challenging to paint with only watercolors. I tried though to get as much of the metallic, reflective feel of it as I could before adding any touches with opaque white.

First, I started by painting in the color gradations on the metal parts following the colorful light reflections. When this was ready, I added some texture touches and then painted in the dark underside of the elevated train line with some structures visible between the bars. Finally, only where it was necessary, I added some highlights with watercolors mixed with white poster color paint.

I left painting the road surface for last, as I knew that adding just the right amount of details to it can be the key to creating the impression of depth. I tried to make the texture in the foreground quite prominent ❹ but painted less, and less of it as the road disappears into the distance.

17 In deep slumber
The steel vibrates gently

沉睡之中

鋼鐵輕輕搖晃

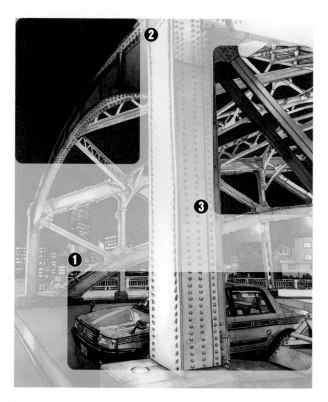

地點

東京都江東區常盤 1 丁目。架在小名木川流向隅田川河口處的萬年橋。

Location

Tokiwa 1 chome, Koto-ku, Tokyo. Mannen Bridge over the Onagi river where it connects to the Sumida river

描繪了什麼？

我在橋上遇到了一台東京標誌性設計的計程車 ❶。計程車司機趁著深夜交通流量少，在前座舒服地睡著了。遠方傳來的城市喧囂聲與橋下緩緩流動的水聲，想必帶領他進入更深層的睡眠。

What

I find this iconic design Tokyo taxicab parked on the bridge, ❶ its driver dozing snugly in the front seat, taking advantage of the (at this late hour) nonexistent car traffic. The sound of the distant city and water flowing gently below lulling him to sleep.

如何繪製？

為了讓明亮的橋與漆黑的夜空形成對比，我使用墨水為天空上色，營造均勻的美麗質感 ❷。在為從鋼架間隙看到的天空等細節上色的時候，墨水也特別好用 ❸。就像這樣，在不同的地方塗上完全一樣的顏色對水彩而言是一件很困難的事，使用墨水則相對簡單。

How

I wanted to contrast the brightly lit bridge with the deep dark sky, so I choose to use my blue-black ink for it's flat, beautiful texture. ❷ This approach also helped with painting in all the small bits of the sky one by one. ❸ It's hard to keep a consistent color like this with watercolors, but it's easy using ink.

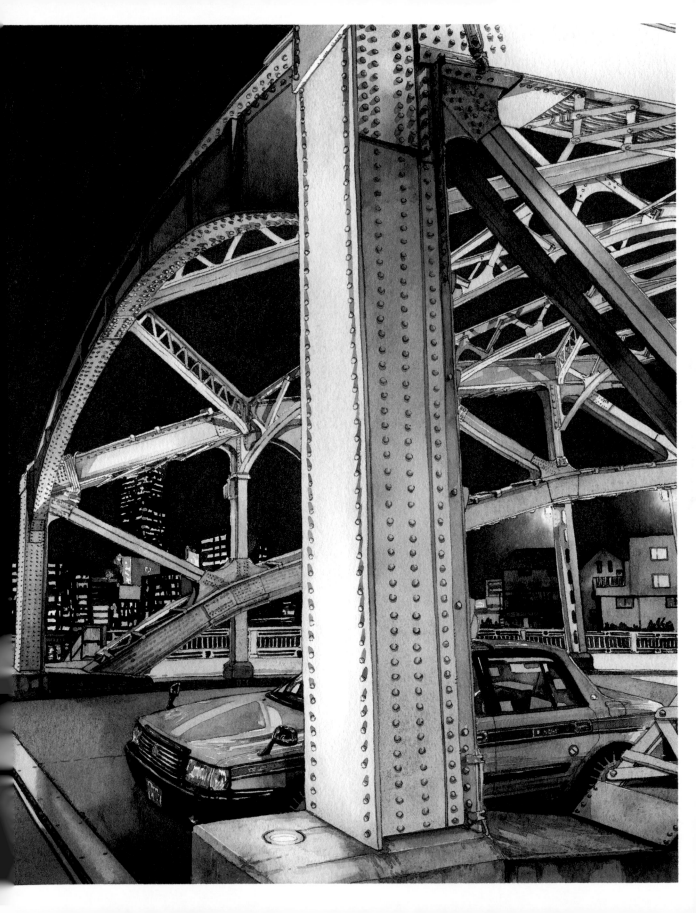

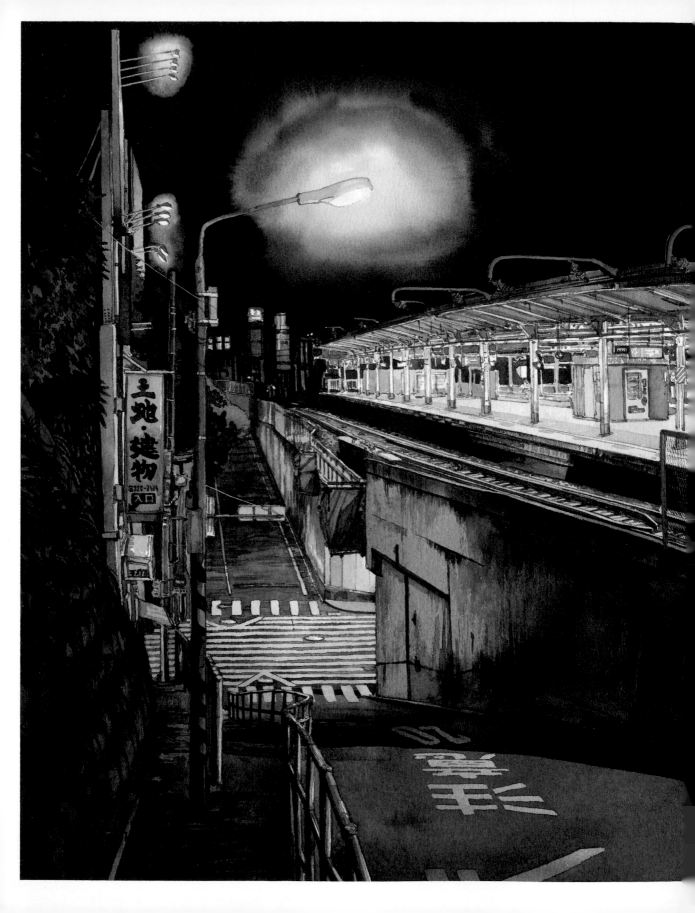

描繪了什麼？

這裡是我們當天外出取景的最後一站。我原本僅是打算進車站踏上歸途，但當我看到漂浮在街道上空的銀灰色月台❶，立刻就決定要把這裡的景色收錄在作品集中。

What

This station is just the last stop on one of our location huntings. I thought that we would only go in and quickly go back home, but now when I see the platform, ❶ brightly lit against the dark sky and looking like it's floating there above the city street, I know that I have to feature it in the book.

如何繪製？

繪製的時候最讓我苦惱的是上方電燈的亮光❷。我想展現這個燈光與漆黑的夜空相比有多麼地明亮，於是決定同時使用藍色的墨水和水彩。藉由稀釋墨水，複雜的漸層也能畫得如此美麗。

How

The light at the top of the illustration ❷ was very tricky to recreate. I wanted to show how bright it was against the black sky so I decided to use the blue-black ink and watercolors together to paint it. Ink can create beautifully complex color gradations when diluted.

地點

東京都荒川区西日暮里３丁目。從間之坂望向西日暮里車站旁的諏訪台通。

Location

Nishi-nippori 3 chome, Arakawa-ku, Tokyo. Looking at Suwadai Street stretching along Nishi-nippori Station from the top of Ainosaka Slope

浮光
旅途的終點

Floating lights 18
At travel's end

下雨的東京

Chapter 4

Rain Tokyo

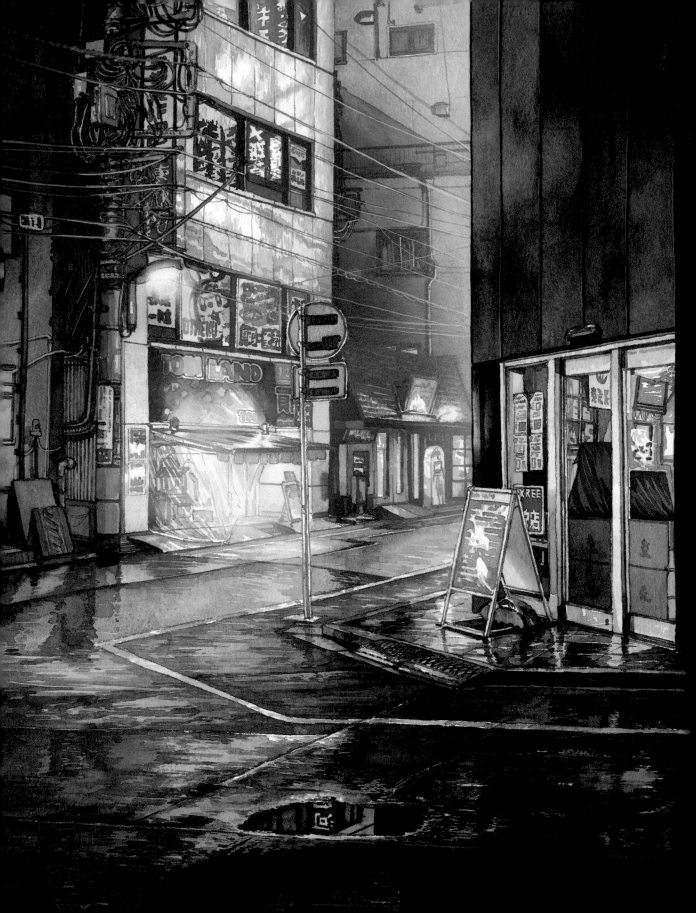

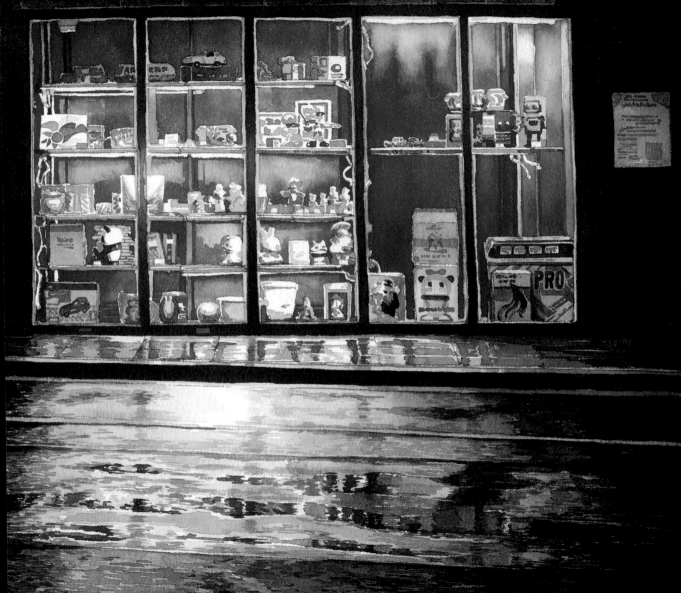

19 | 地點
東京都千代田区外神田 1 丁目。秋葉原電器街的小路。其一。

Location

Sotokanda 1 chome, Chiyoda-ku, Tokyo. An alley of Akihabara Electronic Town, No. 1

描繪了什麼？

　　這是在某個下雨天外出取景時遇到的風景。當時秋葉原路上還有一些人來來往往，部分商店也還開著。等到街上幾乎沒有人之後，我們又再度回到這裡。商店拉下鐵門，路上一片漆黑，看起來非常無趣。好在我之前就已經拍下了這個光線。

　　紅色的櫥窗❶在幾乎全黑的牆壁裡閃閃發光，地上積水反射的倒影理所當然似地吸引了我。明亮的櫥窗擺滿電子零件、動畫和漫畫的周邊商品，以及各種復古的雜物。這些也是吸引人們來到秋葉原的原因之一。

　　雖然還沒有下雨，但我希望為這個景色增添有如霧一般的夢幻氣氛，創造獨特的風格。天氣不好的時候，有些商店會掛上防水塑膠布❷保護商品，這讓周遭看起來更有個性。

What

I take this reference photo while walking around Akihabara on the rainy day location hunt. At this hour there are still some people roaming around, looking into few of the late open stores. We came back to this place later when the streets were almost empty, but then the shops were also dark and dull, so I was lucky to capture some of this light at this time.

The red display case, ❶ bright in the almost black wall of the shop, reflecting in some puddles is what first catches my eye in this scene. Lit shop windows like this one, full of electronic parts, anime and manga goods or just various retro tat are one of the things we especially came for to Akihabara.

Even though the rain is not yet falling so thickly, it gives this scene it's dreamy, foggy atmosphere uniquely transforming the shopping district. In the rain, some stores protect their wares by putting on transparent plastic tarps ❷ on the stuff displayed outside, which adds even more character to the surroundings.

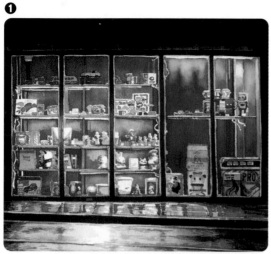

如何繪製？

紅色櫥窗 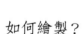 是這幅畫中我最期待描繪的部分。然而，為了不讓牆壁的暗色與亮色混合 ❸，必須從旁邊被照亮的街道開始畫。我花了整整一天從明亮且帶點藍色的牆面開始畫，接下來是反射複雜的窗戶 ❹，最後是前面暗色的電線桿。另外，我只用藍色調描繪透明塑膠布和裡面的商品 ❷。

接下來終於要畫櫥窗了。光線打在玻璃上，為了描繪玻璃後面的商品，我決定不要畫線稿，僅用水彩表現。我用留白膠畫出商品的形狀並填滿，這個技巧讓我毫無阻礙地為背景塗上紅色，同時畫出經過燈光照射呈現的淡色和橙色漸層。

How

The display case ❶ was the part of the painting I wanted to get to the most, but the bright street had to be painted first to avoid colors mixing in from the dark wall. ❸ This part alone took a full day of work starting from the brightly lit bluish wall, through the windows full of complex reflections ❹ to the dark utility pole in front. I also tried to recreate the look of the transparent plastic sheet and things behind it using only shades of blue. ❷

Finally, it was time for painting the display case. To get the softly lit, behind-the-glass feel on the items inside I decided to paint them with only watercolors and no pen lines. To do this, I used masking fluid on all of them first to determine their shape and to be able to paint the red background unhindered. With this approach, I was able to recreate the lighting effect of very intense red color getting paler in places where spotlights are shining on the wall.

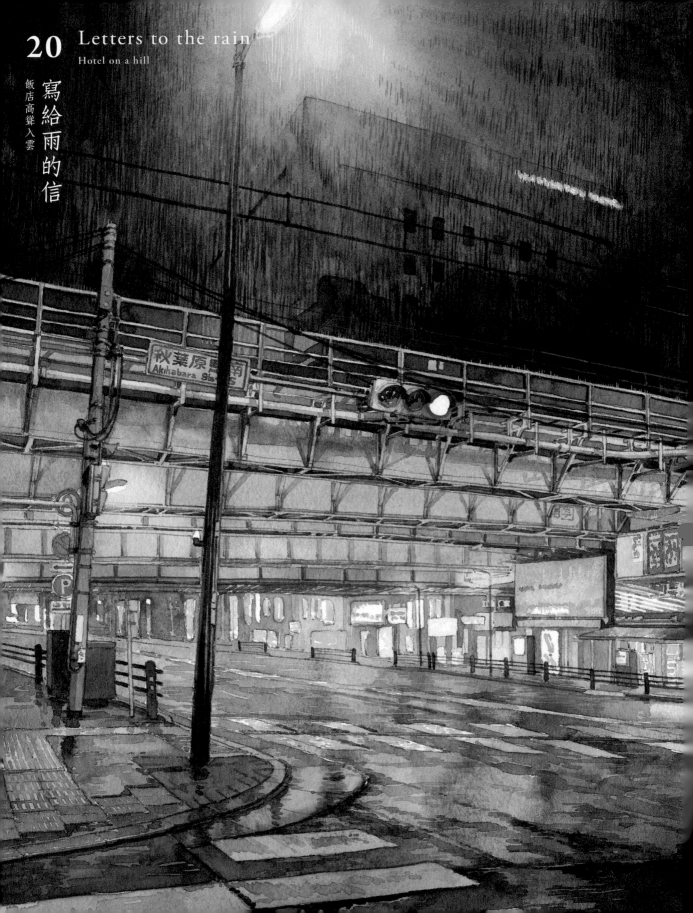

20 | 地點
東京都千代田区外神田 1 丁目。從秋葉原車站南側
紅綠燈前看到的JR高架橋和餐廳。

Location

Sotokanda 1 chome, Chiyoda-ku, Tokyo. The view of an elevated
JR railroad and restaurants from the front of the southern traffic
lights of Akihabara Station

描繪了什麼？

當你有意識地環顧四周時，就會有新的發現，這
幅畫就是最好的例子。

我經常前往秋葉原，有時是為了買東西，有時是
為了尋找動畫或漫畫的靈感，又或者只是隨意散步。
當然，我也曾走過這個十字路口，但在「尋找有趣景
點」的目標之下，第一次注意到這座引人入勝的橋和
充滿復古情懷的商店及餐廳。

四周建築物上多彩的看板和招牌相互爭妍鬥豔。
特別吸引我的是橋旁邊老舊的霓虹燈招牌 ❶（在東京
越來越少見），以及右邊餐廳巨大鮮豔卻又不做作的
活字 ❷。

最後，為了增添更多下雨的氣氛，我注意到橋後
方有一棟飯店，消失在有如霧一般的空間裡 ❸。在尋
找以雨為主角的場景時，我特別注意這樣的細節。

What

This picture is an example of how making an effort to be
more conscious about the surroundings usually makes a
difference and allows for new discoveries.

I have been to Akihabara many, many times to buy things,
to look for animation and comic inspirations, and to just
walk around. I have been here, on this crossing too, but only
now that I'm looking for interesting sights, I can not fail to
notice the awesome bridge nor the retro-looking shops and
restaurants.

The lettering and many colorful signs stand out from the
surrounding buildings. I'm especially drawn to the old school
neon signs ❶ (something that is becoming more and more
rare in Tokyo) next to the bridge and the huge, colorful but
straightforward typography on the right restaurant. ❷

Lastly, to add even more of the rainy atmosphere to this
scene, I spot the large hotel building behind the bridge, ❸
disappearing into the foggy distance. During this rain-driven
location hunting walk, we are especially looking for such
details.

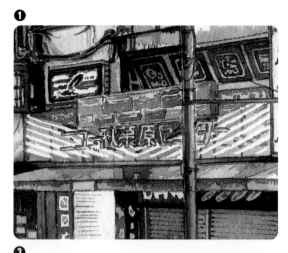

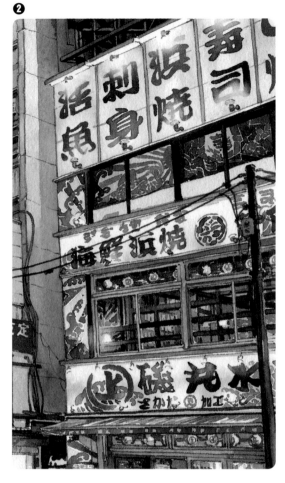

如何繪製？

這幅畫是雨系列作品中最耗時的一幅。理由之一是建築物和橋等元素的結構太複雜。另外，還有許多細節繁雜，卻必須忠實還原的標誌和看板 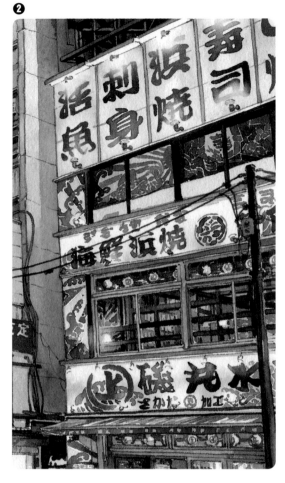。

我分成好幾層作畫，使用留白膠或很淺的鉛筆線當作指引，慢慢描繪。我的目標不僅是要忠實還原招牌的內容，更希望呈現在不同燈光照射下散發的各種氛圍。

另外，描繪幾乎看不見的細雨紛飛也同樣重要。為了營造下雨的氛圍，我在橋以上的部分，用細緻的筆觸畫出霧雨般的感覺。

在最後潤飾的階段，我用不透明的顏料在明亮的地方加上雨的質感，又為橋和電纜線增添亮點。

How

This was one of the pieces that took the longest time to complete. Not only because of the complex shape of things like the bridge or the buildings. The sheer amount of difficult and detailed signs and lettering that had to be recreated took a great toll. Especially that on most of the billboards' elements, I did not use any linework to guide me. ❷ I had to paint in many layers, using tricks like the masking fluid or light pencil guides for help. The goal was not only to recreate the contents of the signs but also how the many spotlights shine on them.

It was also essential to me to make the painting represent the atmosphere of the rain falling so fine that it was almost invisible. I covered the top part of the picture in thin rain-like paint strokes to express this.

To finish the whole painting, I decided to add some opaque white paint strokes in the bright areas of the rain texture and some highlights on the bridge and cables.

（參照）《東京夜行》製作過程）152 頁

cf.「How it was made」Page152

兩個車站
無法前往的地方

21 Two stations
Where I cannot go

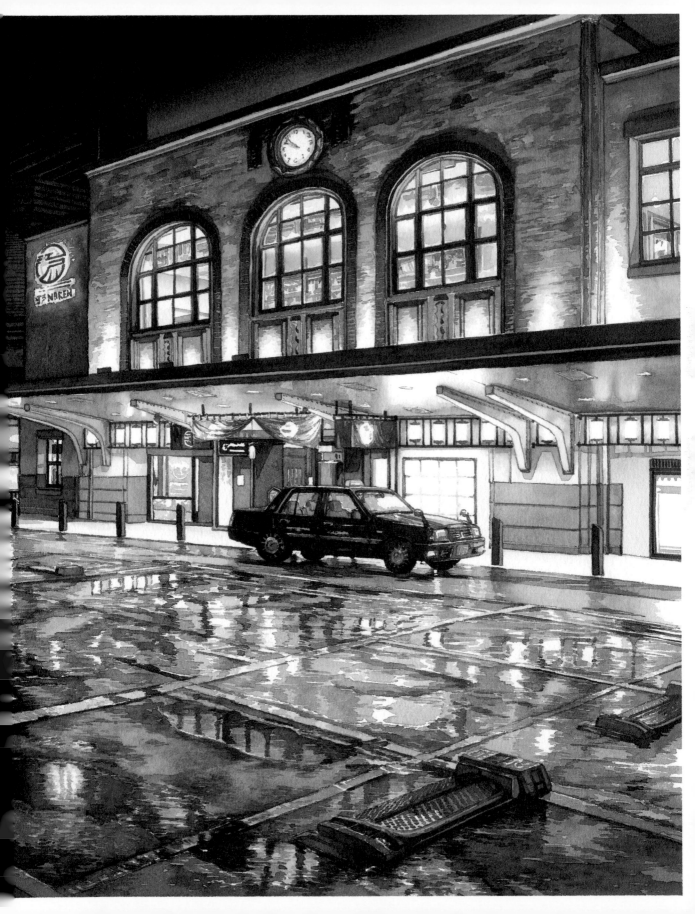

21 | 地點
東京都墨田区横網1丁目。兩國車站西口圓環。依稀浮現的國技館。

Location

Yokoami 1 chome, Sumida-ku, Tokyo. View from a roundabout at the west exit of Ryogoku Station with a silhouette of the Kokugikan Hall

描繪了什麼？

我們為了確認江戶東京博物館晚上的樣子，中途經過兩國車站旁邊的路。我喜歡這種帶有現代風格的復古設計。夜晚雨中靠近一看，發現這棟建築物更加明亮耀眼。被雨淋濕的停車場，上面的倒影看起來像是施了魔法一般有魅力。

另外，溫暖的光線與浮現在背景暗空中的幾何形壯麗建築物形成對比，更讓我們停下腳步。

我很高興拍照時剛好有一台看起來很孤寂的計程車❶停在車站前，這台東京隨處可見的計程車成為這幅畫最完美的焦點。

What

As we walk to check how the Edo Tokyo Museum looks at night, we happen to pass right next to Ryogoku Station. I like the renovated retro-like design of the building, especially now, when we approach it after dark and in the rain. Shining brightly and reflected in the wet parking lot, it's looking almost magical.

What's more, the building's warm light is creating a stark contrast with the dark sky and black, geometrically imposing buildings in the background. This view stops us in our tracks. Taking photos, I'm glad that I caught the solitary black taxi cab ❶ just waiting there in front of the station. This car, so ubiquitous around Tokyo, is adding the perfect focal point, a necessary element to make this scene complete.

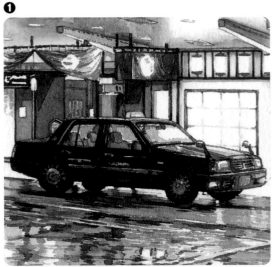

如何繪製？

或許是我特別鍾情於復古建築（又或是我一直在畫水泥和鐵製的東西，需要換換口味），我非常期待描繪這棟建築物明亮的內部和漆黑的外牆，以及圓弧形的窗框。

接下來我努力忠實地描繪積水裡的倒影，尤其注意顯眼的細節，例如藍色的標誌 ❷、明亮的裝飾用燈籠、圓弧形的暗色窗框等，將這些元素適當排列，倒影看起來也更真實。

為了讓後方的建築物融入黑夜之中，使前方的車站看起來更顯眼，所以我混合暗色顏料，用噴槍上色，如此一來顏色更均勻 ❸。

How

Maybe it's because I love this kind of retro buildings (a nice change from all the steel and concrete), but I had a lot of fun recreating the station. I first painted the bright insides and then the dark walls, leaving the rounded window frames for last.

Next, I put some effort to make the water reflection colors, and details correspond accurately with the building. I was especially careful with prominent details like the blue logo, ❷ entrance adorning bright lanterns, and round windows dark frames. When things align properly, it makes reflections so much more believable.

To make the back structures disappear into the darkness, and the station building more prominent, I used a mix of dark watercolors with the airbrush to give this part a more uniform look. ❸

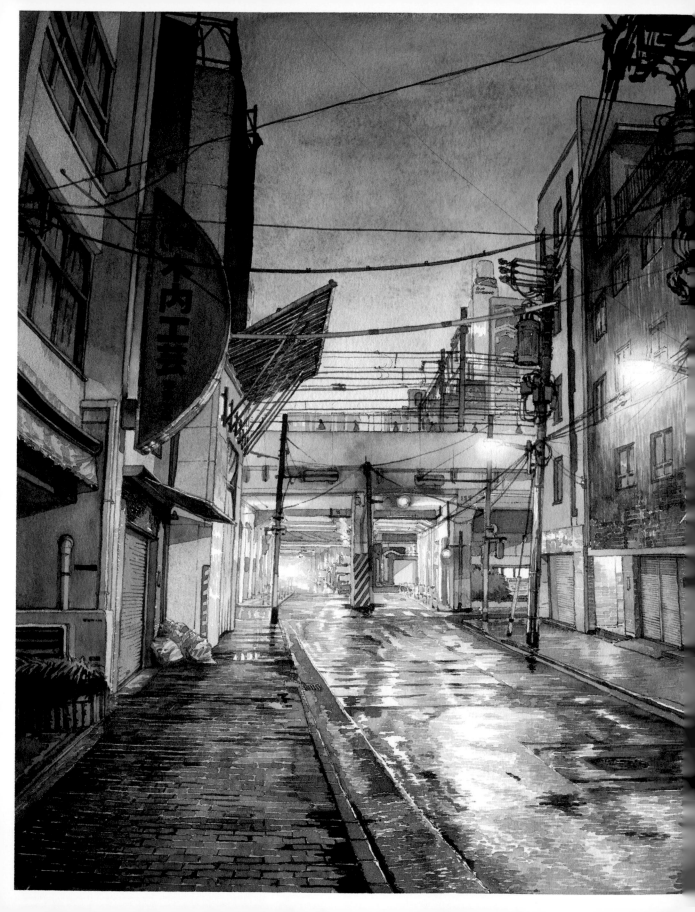

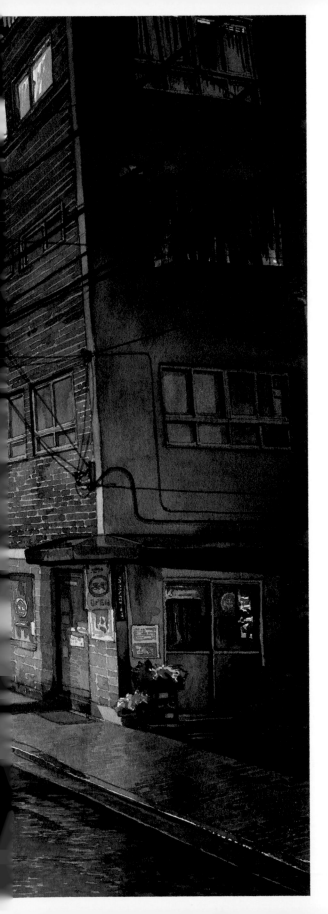

光之河
綠色與紅色

A river of light **22**
Green and red

22 地點
東京都台東区上野 3 丁目。秋葉原與御徒町中間。
從練成通望向JR高架橋西側。

Location

Ueno 3 chome, Taito-ku, Tokyo. View of the western side of an elevated JR railroad from Rensei Street, between Akihabara and Okachimachi

描繪了什麼？

　　我們在漆黑無人的街道上，因為想要在秋葉原多拍一點照片而準備往回走，這時下起了雨。走著走著遇到了隨著號誌燈時而紅時而綠的鐵道橋。

　　鮮艷的顏色反射在淋濕的柏油路上，看起來就好像是一條發光的小河❶。然而，周圍的建築物黑暗沉重，散發空虛的氣氛❷。

　　紅燈的時候，溫暖的光線與冷冽的綠色建築物衝突，創造出美麗的對比。為了捕捉這個特殊的氛圍並呈現在畫作當中，我按下了快門。

What

The rain finally starts falling in earnest while we walk some dark and empty streets, going back to take more photos in Akihabara. On our way, we stumble upon this brightly lit railway bridge with some traffic lights switching from vibrant red to green and back again.

The colors reflect in the wet pavement making the whole street glow like a bright river, ❶ but the surrounding buildings retain their glum and dark appearance, imposing and seemingly empty. ❷

When the traffic lights change to red, they create a beautiful contrast of warm glow emanating from the bridge, fighting with the greenish, cold look of the opposing buildings. I take a photo meaning to capture this unique atmosphere later, in a painting.

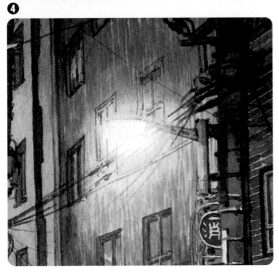

如何繪製？

　　為了與周圍一片漆黑的建築物形成對比，我決定將天空塗亮 ❸。這裡我使用的是具有顆粒性、名為「陶瓷粉」的暗紅色，再混合暗藍色，如此一來就可以在天空畫出特殊像雲一般的紋理。

　　比起參考用的照片，我希望強調兩側建築物 ❷的不安定性，因此我決定讓它們稍微向內傾斜，創造類似魚眼的效果。我希望藉此讓中間的高架橋看起來比周圍的景色脆弱。另外，我在街燈周圍輕輕畫了幾條直線 ❹，加強降雨的效果。

How

I tried to paint the sky bright in this piece ❸ so it would contrast with the surrounding dark buildings. To do this, I used a dull red, beautifully granulating (the pigment particles are visible after the paint dries) color called "Potters Pink." Mixed with some dark blue it gave the sky a bit of that unusual, cloud-like texture I was looking for.

The buildings on both sides ❷ should look even more ominous than in the reference photos. I decided to make them lean slightly inwards, simulating a fish-eye lens effect. With this, the bright light of the bridge feels even more vulnerable. I also added some light, vertical strokes of paint around the bright street light on the right ❹ to mark the falling rain.

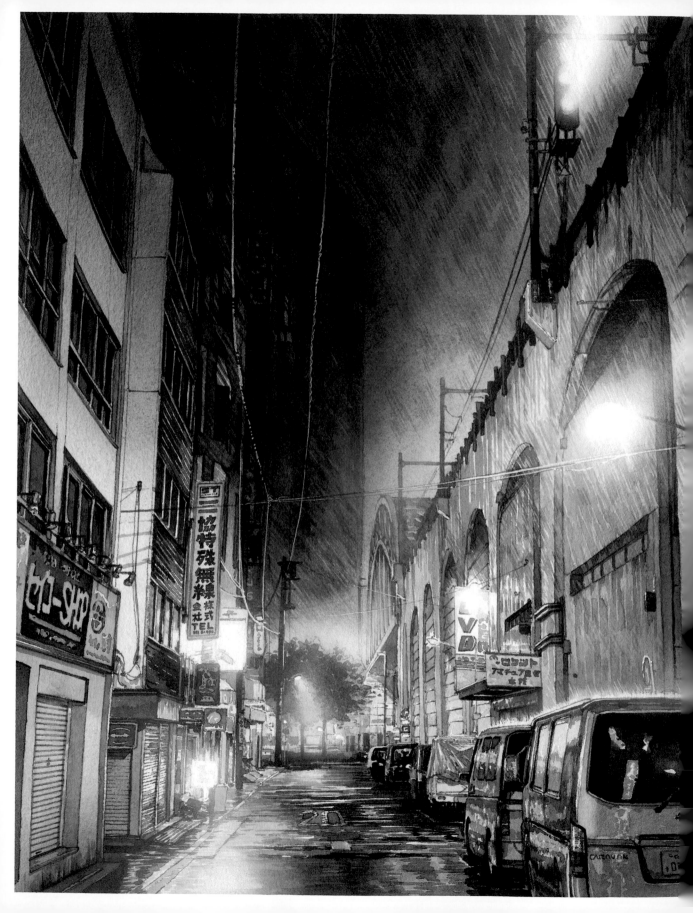

描繪了什麼？

大樓、街道和高架鐵軌逐漸消失在遠方。遠方聳立的漆黑建築和橋❶更是模糊，幾乎看不清。我希望捕捉這個街景散發出的平靜氛圍。

What

Buildings, the street, and the highrise train tracks gradually disappear into the rainy distance. The vast dark office building and the railway bridge, ❶ become blurry and only barely visible in the background. I'm captivated by the calm feeling emanating from this night street scene.

如何繪製？

用細的筆觸描繪天空和畫作右側❷（尤其是燈光附近），創造出下雨的效果。亮點部分除了在紙上留白之外，最後也使用白色顏料，描繪雨打在車頂的樣子❸。另外也用噴槍加強遠方依稀可見的模糊燈光。

How

I decided to cover the sky and right side of the piece ❷ (especially around the lights) with a delicate pattern of thin brush strokes to show the falling rain. I also left some white highlights and used white paint to show the raindrops hitting the car's roof ❸ and (with the airbrush) for the foggy light in the distance.

地點

東京都千代田区外神田 1 丁目。總武線的高架旁。東側同時可以看到昌平橋的拱橋。

Location

Sotokanda 1 chome, Chiyoda-ku, Tokyo. Along the elevated railroads of Sobu Line with eastern side of the arch-shaped Shohei Bridge in the distance

綠色的記憶

消失在雨中

Memory of green 23

Disappearing into the rain

24 The gate

It's full of stars

滿天星斗

門

描繪了什麼？

深夜裡，秋葉原知名的小路上，逛街的人潮和觀光客被大雨趕跑，而我們為了多拍幾張照片而折返，也因此看到被雨淋濕的柏油路上的倒影 ❶，這也正是我一直希望可以捕捉到的景色。

What

Once it got very late all the shoppers and tourists roaming around Akihabara's popular backstreets were chased away by the now quite steady rain. We come back to try to take some more photos. Now, I can finally clearly see the gorgeous reflections ❶ in the wet pavement I was hoping to capture.

如何繪製？

為了讓焦點集中在中央的橋，首先我「壓縮」兩旁的大樓，創造透視感變形的效果 ❷。

另外我也試著營造距離感，尤其為了描繪因雨而變得模糊的建築物 ❸，我混合白色墨水和藍綠色的水彩顏料，再用噴槍上色。

How

To put more focus on the central bridge part, I first made it more prominent by modifying the perspective of the scene, "squishing" the side buildings. ❷
I also tried to recreate the sense of distance with the background structures disappearing into the foggy air ❸ by airbrushing some white ink mixed with a blue-green watercolor.

地點

東京都千代田区外神田 1 丁目。秋葉原電器街的小路。其二。

Location

Sotokanda 1 chome, Chiyoda-ku, Tokyo. An alley of Akihabara Electronic Town, No. 2

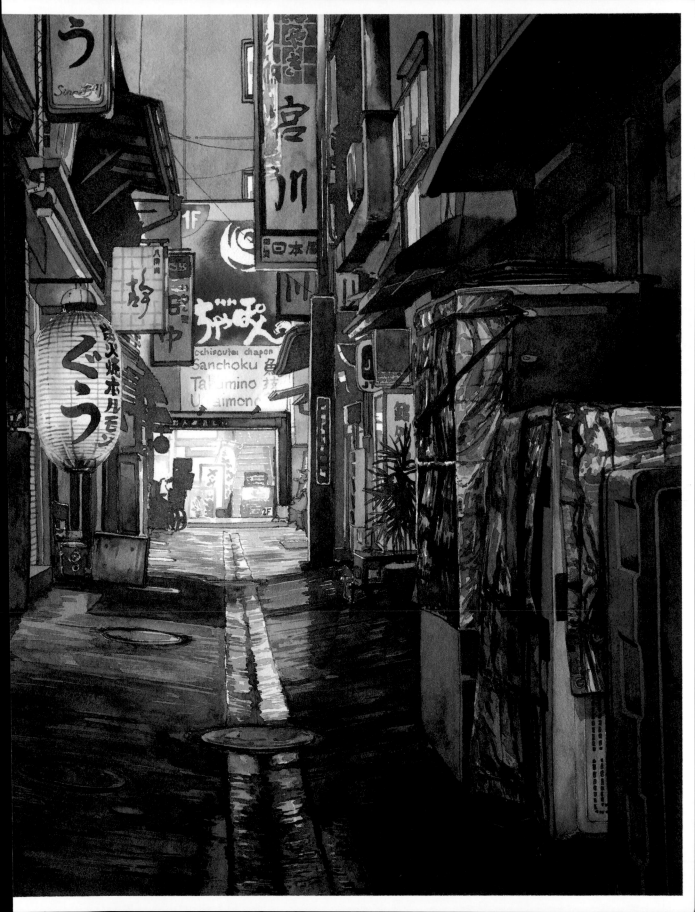

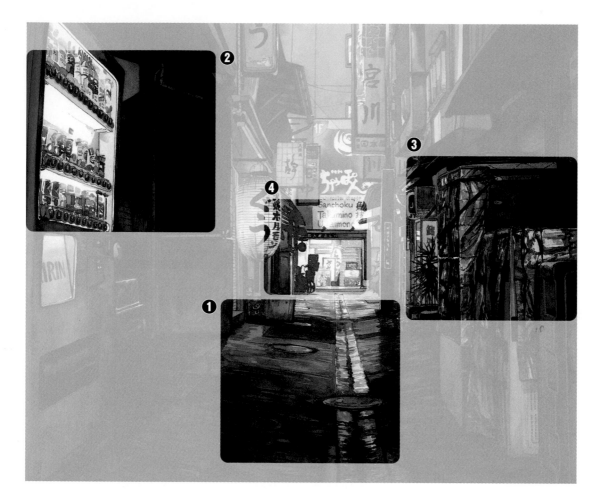

25 | 地點
東京都中央区八重洲 1 丁目。八重洲北口通隔一條街的小巷子。

Location
Yaesu 1 chome, Chuo-ku, Tokyo. In an alley located one street off Yaesu North Exit Street

描繪了什麼？

我在這條巷子裡發現的排水溝和閃閃發亮的平滑水泥牆非常美麗❶，讓人無法忽視。

後方散發獨特風情和溫暖光線的商店以及大型紙燈籠，就好像在邀請我前往探險。

另外，抬頭可以看到滿滿都是商店招牌。這些招牌的設計和文字，為這幅畫增添難以言喻的趣味。

當然，包括四周自動販賣機裡的各種寶特瓶和罐裝飲料❷在內，僅僅是放置在一旁的商店備品❸也是必須仔細重現的重要元素。

What

So much beauty in this back lane, it's gutter, and the gently sloping concrete on both sides, shining so brightly ❶ that I just cannot ignore it.

The peculiar warm quality of the light emanating from the shops in the background and the huge paper lantern are inviting us to explore.

To top it off, I know that the bright shop sign closing the lane, with its design and lettering will add even more of this strange character to the scene.

I also, of course, can not pass on featuring and later carefully recreating all the colorful drink bottles, and cans in the vending machine ❷ and the various shop equipment just stored there on the street. ❸

如何繪製?

　　我特別注意紋理、光源、反射，盡量讓前景的各種元素看起來更豐富且寫實。另外，關於中段部分的建築物，我刻意不描繪細節，保持簡單。接下來，我單用深藍色墨水描繪遠方腳踏車在背光下的剪影 ❹。

　　我用這樣的方法呈現深度和透視，希望能夠引導看畫的人深入走進巷子裡。

　　這幅畫的整體景色偏暗，幾乎看不見天空，也只有少數幾個明亮的元素。為此，我找出所有可能的光線，在塗滿水彩的畫紙上保留部分空白，讓它發光。

How

In this painting, I put a lot of attention to textures, lights, and reflections on the objects in the foreground. I wanted to make them look as rich and realistic as I could to then leave the details of the back buildings flat, and simple. I also used only the deep blue-black ink to color in some flat, silhouette-like backlit shapes ❹ in the distance.

With this, I tried to recreate the sense of depth and perspective in this painting, guiding the viewer deeper and deeper into this back alley.

This location made an overall dark scene, with just some bright elements and no sky at all. I tried to capture the light wherever I could find it, leaving highlights unpainted, letting the white of the paper shine.

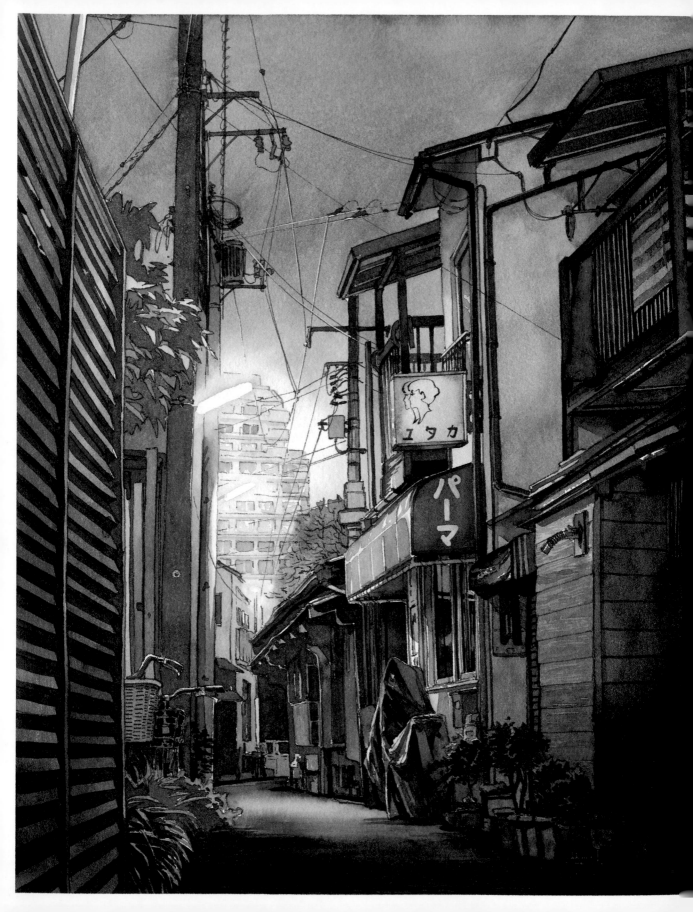

遠處的光線與黑暗的人影

兩顆頭

The two heads 26

A distant light, a dark figure

26 | 地點
東京都台東区谷中 7 丁目。從御殿坂往下走，通往上野的近路旁小巷。

Location

Yanaka 7 chome, Taito-ku, Tokyo. In a narrow alley that runs from 　nzaka towards Ueno

描繪了什麼？

　　在東京的眾多地方之中，我曾多次來到此處，每次前來都在摸索不同的描繪方式。我非常喜歡這間擁有奇妙老舊看板和紅色屋簷❶的理容院，與周圍的民房相比非常顯眼。我從以前開始就經常利用白天的時光在附近散步，總是忍不住停下腳步拍照。

　　最終，夜晚的氛圍為我的創作困境找到解答——當我在深夜時分看到這條路，發現這裡藏著深奧且不可思議的氛圍，就立刻認定要把它收錄在作品集中。

　　好多人都跟我說，蓋上遮雨布的腳踏車❷看起來就好像是靜待在街角的死神。我自己也無可否認。

What

This narrow alley is one of the places in Tokyo I found myself returning to, many times in the hope of finding a way to paint it. I love the hair salon with its weird, retro-looking sign and red marquee ❶ that stand out so much from the surrounding houses. I took many photos here, during the day, always stopping by while on a walk in the vicinity.

Finally, the night comes to answer my creative dilemma — when I see how much more profound and weird atmosphere this street has when it's dark, I know I have to feature it in this series.

Few people said that the bicycle covered with a rainproof sheet ❷ looks a bit like a death-god just waiting calmly on the street corner. I cannot deny it.

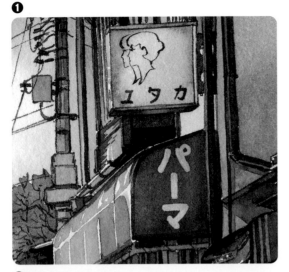

如何繪製？

我仔細玩味所有在這裡拍攝的照片，決定利用左側圍柵和前方建築物的透視線，引導人的視線直接看往紅色屋簷和看板。

為了把焦點放在理容院的前方，我使用彩度最高的強調色，讓那裡看起來最明亮❶。

我也想呈現大都市東京就在這條路的盡頭，因此稍微調整了遠方大樓❸的位置。實際上從這個角度看不見這棟大樓。

How

I made many photos here and finally decided on this composition that leads the eye straight to the red marquee and the sign using the perspective lines of the fence on the left and the buildings in the foreground.

The front of the hair salon is the most brightly lit and the most saturated color accent ❶ of the illustration. I used it to achieve a sharp focal point, but I also wanted to show that the vast city of Tokyo is there, somewhere in the distance.

To solve this, I moved a little the big building visible in the background ❸ — in reality, you can not see it from this angle.

秘密

影子的嬉鬧

27 Secrets to tell
Gentle play of shadows

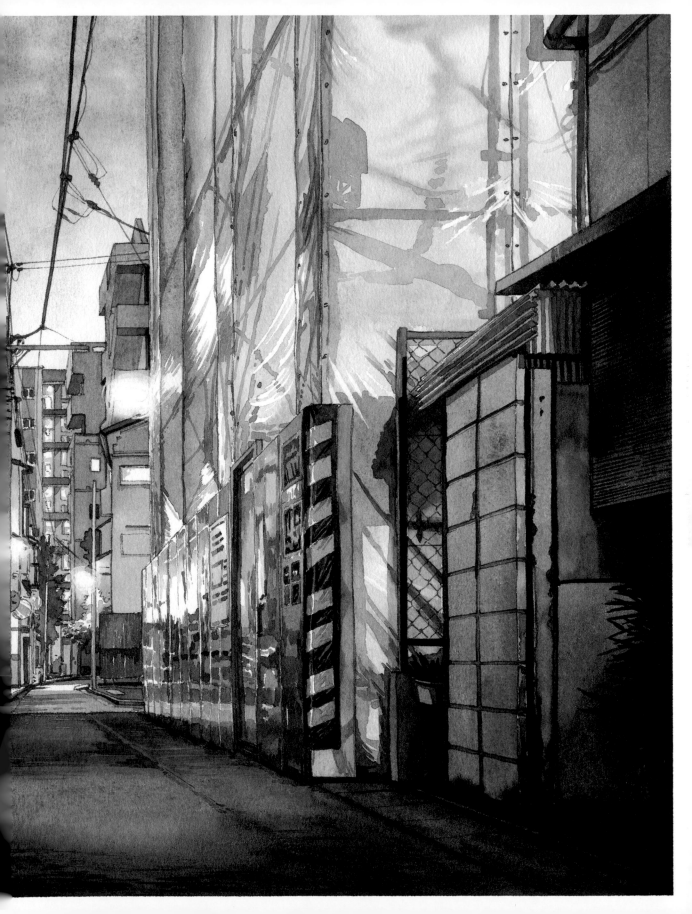

27 | 地點
東京都荒川区東日暮里４丁目。連接鶯谷車站和三河島車站的尾竹橋通附近。其二。

Location

Higashi-nippori 4 chome, Arakawa-ku, Tokyo. Near Otake-bridge Street that connects Uguisudani Station and Mikawashima Station, No. 2

描繪了什麼？

　　灑在街道上的溫暖陽光照亮小小的階梯 ❶，遠方還可以看見幾棟建築物。出乎意料地，這些是這個場景最初吸引我的元素。

　　架起相機，我發現工地創造出的光、影，以及反射，展現美妙的演技 ❷。

　　左側建築物粗糙不平的金屬外牆與右側如鏡子一般的平滑表面，在街道深處光線的照射之下，呈現完全不同風貌的反射，兩者的對比竟是如此美妙。

What

Surprisingly, it's the small staircase on the left side ❶ of this street, lit with warm light and some of the buildings in the distance that pique my interest in this scene.

When I try to take a photograph here, I spot the delicate play of light, shadows, and reflections on the right construction site wall. ❷ I decide that I have to include it in the painting.

The different textures in both of those parts are also what makes this scene worth attention, creating a great contrast. The metal walls of the left building — coarse and wavy. The plastic barrier on the right — slick and reflecting the light from the back buildings in a completely different way.

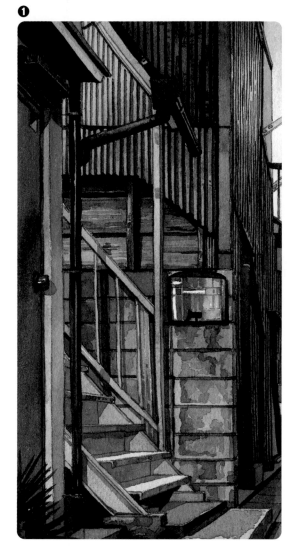

如何繪製？

　　為了描繪映照在工地塑膠布上的輕柔影子❷，我首先塗上米灰色的漸層打底。在薄塗尚未完全乾之前塗上影子的顏色，這是名為「濕加濕」的水彩技法。如此一來，相互交融的顏料可以創造出輪廓模糊的柔和形狀。另外，在最初的薄塗完全乾了之後，再描繪清楚的影子，呈現位於塑膠布內側遠近不同的鋼架，創造出透視感。

　　在進行以上步驟的時候，我刻意在畫紙的部分位置留白，藉此營造出塑膠布的垂墜感。

　　另外，光線在塑膠布上的反射❸、波狀金屬外牆在樓梯燈光照射下呈現的樣子❶等，為這幅作品帶來非常重要的紋理，因此我特別用心描繪。

How

For soft shadows on the construction site's protective tarp, ❷ I used the "wet-on-wet" watercolor technique. I painted the base grey-beige color gradient first and then, before it dried completely, added the darker shadows. The paints would mix just enough to produce soft contours. After this part dried thoroughly, I then added some hard shadows too, for the illusion of close and far scaffolding inside.

While doing those steps, I was careful to leave some of the paper unpainted for the white highlights reflecting the shape of the slightly sagging fabric.

I also paid close attention to the important textures, like the way the plastic protective corner marker reflects the light ❸ or how the stairway lamp lights the corrugated metal wall. ❶

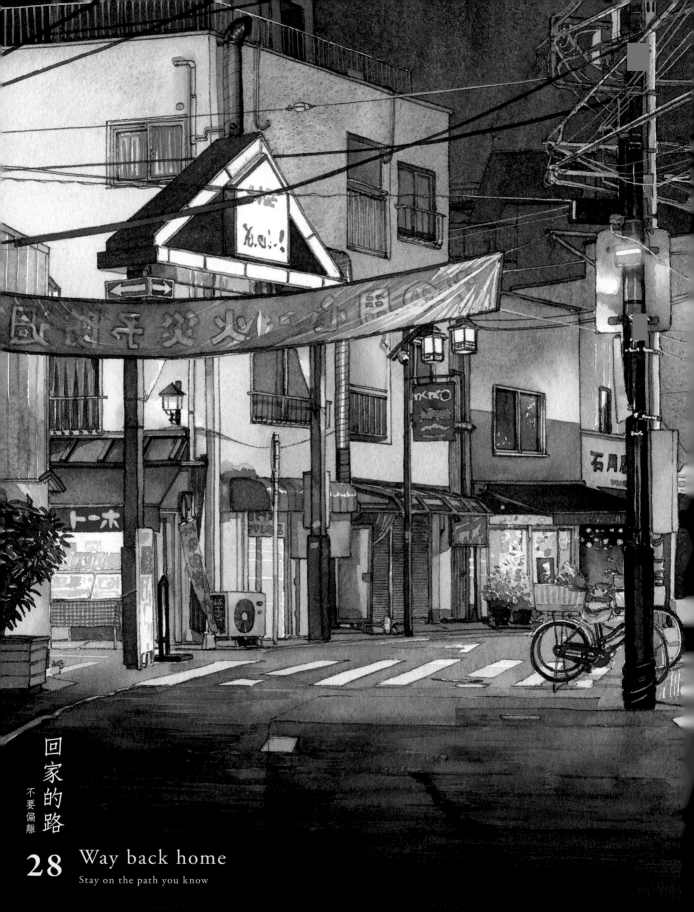

回家的路
不要偏離

28 Way back home
Stay on the path you know

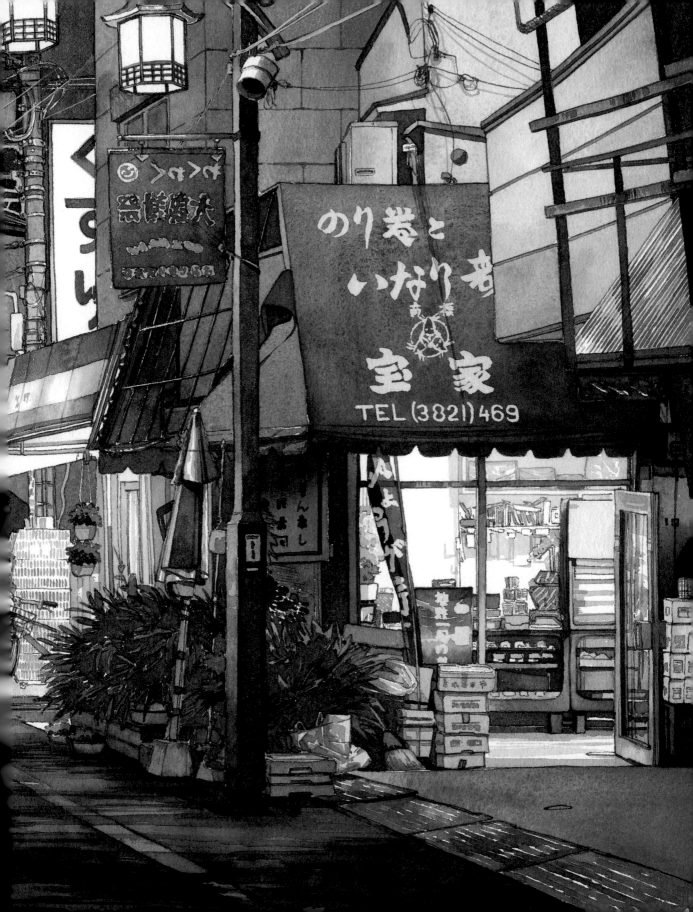

28 | 地點
東京都文京区千駄木３丁目。從谷中銀座向北走進夜市通。

Location
Sendagi 3 chome, Bunkyo-ku, Tokyo. Walking down Yanaka-ginza and turning towards north at Yomise Street

描繪了什麼？

本書《東京夜行》收錄的畫作，都是受我和KANA從公司散步回家的路上所看到的風景啟發，希望透過水彩畫呈現當時的氛圍。

例如深夜散步的時候，明明是熟悉的街道，卻感覺有些奇妙，甚至令人害怕❶。曾於白天多次造訪的商店，只是因為到了深夜，突然間看起來有些詭異和空虛❷。繞道的小巷也不再具有魅力，聽著自己之外的腳步聲，不自覺地加快腳步。

確認取景時拍攝的照片，我發現這個場景的光線、街道本身，以及沒有人的商店等，完美的組合讓我想起當時的心情。空蕩蕩的街上響起的聲音與遠方都市傳來的喧囂聲合而為一，我希望藉由畫作呈現這樣的感覺。

What

The illustration series, on which this book is based, was inspired by my and Kana's late-night walks on our way home from work. I wanted to paint some views of Tokyo's night streets that would be reminiscent of those late evenings.

We are just walking alone, at a very late hour, going along streets that even though we know them perfectly well, look a bit odd and scary. ❶ A shop that we might have visited often during the day time can suddenly seem a bit eerie and weirdly empty ❷ at this late hour. The dark side alleys do not seem so inviting any more. We quicken up the pace just a bit while listening for footsteps other than our own.

The moment I saw the photos we took here, I thought that the lighting in this scene, the street itself and the empty shop created the perfect mix to invoke this kind of feelings.

I also aimed for a picture that would almost make one hear the sounds of the empty street with the distant rumble of the vast city beyond.

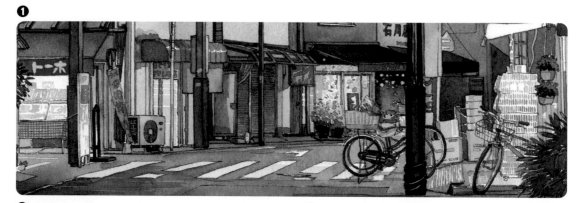

❶

❷

❸

❸

如何繪製？

　　各種看板和垂墜的布條，對於這個場景來說非常重要。如果能夠順利描繪其顏色、形狀、字樣，便能為這幅畫增添真實感。

　　我看著參考用的照片，思考著如何描繪垂墜布條時，仔細觀察了上面的文字，發現了一個問題。背面照過來的燈光讓布條呈半透明狀，加上亮色的文字和圖樣，以及漆黑的背景。這個組合對水彩來說難度很高。首先我為文字上色，接著小心地塗上留白膠後，再塗上暗紅色底色。我也特別留意布條的形狀，留下亮點同時，也畫上多道影子，最後再加上風化*效果。

　　與實際看見的風景相同，描繪出從背面看到的半透明垂墜布條 ❸。

*風化：創造斑駁與風化效果的手法。

How

The various signs and banners were vital to this scene. If the colors, styles, and fonts are well painted, they can add a lot of realism.

I took my time studying the lettering in the reference photos to figure out a way to paint the signs. I had to deal with partly transparent, backlit fabric with text and logos, that were made of bright shapes on dark backgrounds — a challenging combination for painting with watercolors. I colored the letters first and carefully covered them with masking fluid to be then able to paint the dark red backgrounds. I added shadows following the shape of the fabric and painted in a bit of weathering as the last step.

Some of the signs are written backward because I decided to recreate them in the painting as they were in the scene — we can see the back of the half-transparent banners. ❸

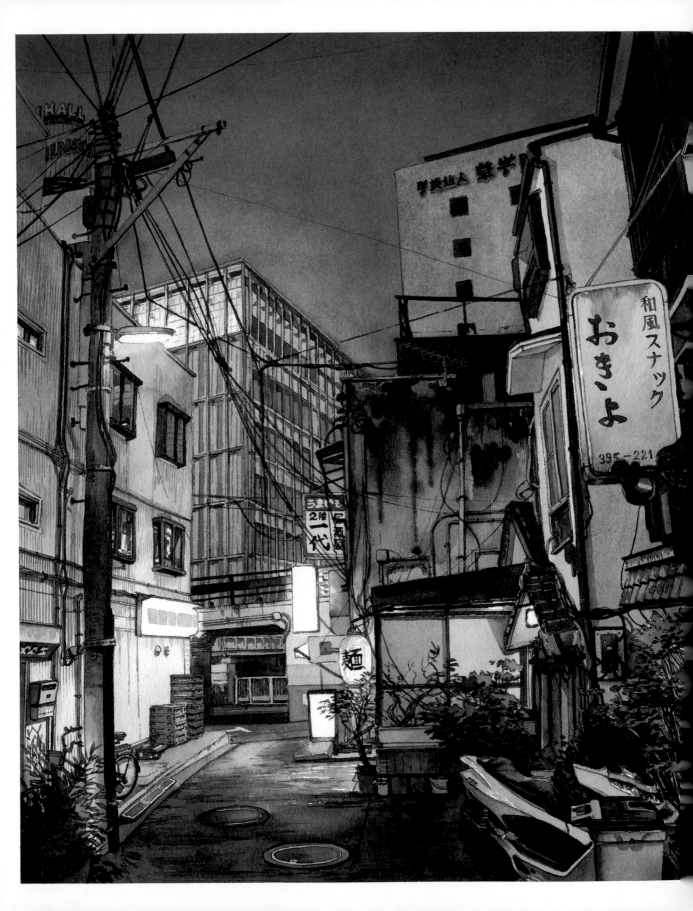

描繪了什麼？

車站附近一條平凡無奇的小路。這裡有許多小酒吧和營業到很晚的餐廳。我從各種角度拍了許多照片，試著捕捉每一家店的氣氛。最終我選定最符合「夜晚的東京」概念的景色與兩棟高大的建築物 **❶**。

What

I spot this ordinary back alley close to a train station, filled with small pubs and late open restaurants. Wandering between the buildings and taking a lot of photos, I try to capture the atmosphere of all the shops. In the end, though, I decided to paint this angle, including two large buildings visible in the distance. **❶** They add a bit of the needed "night Tokyo" context to this scene.

如何繪製？

我盡可能地忠實描繪畫面前方的植物、商店看板，以及機車的細節 **❷**。畫面後方看到的則是有如高塔一般聳立的冰冷建築物與寂靜的灰色天空。我藉由這樣的前景與後景背景，營造對比的效果。

How

I add plenty of details to the street and shops in the foreground, meticulously painting things like plants, shop signs or the motorbike. **❷** I do this to create a contrast between this close part and the high background buildings, cold and towering against the empty grey sky.

地點

東京都台東区根岸 1 丁目。從鶯谷車站附近的紅綠燈，朝上野方向前進的小路右手邊。有許多小酒吧林立。

Location

Negishi 1 chome, Taito-ku, Tokyo. A small street filled with bars close to Uguisudani Station

30 The night is so lonely
Lights so inviting

誘人的燈光
孤獨的夜

地點
東京都台東區谷中 7 丁目。從御殿坂往下,朝上野
方向前進的路上經過的初音小路。

Location
Yanaka 7 chome, Taito-ku, Tokyo. Hatsune Koji, a
narrow, quiet side-alley of a street that runs from
Gotenzaka towards Ueno

描繪了什麼?

　　酒吧林立的小路與木製拱廊❶。我被這個
充滿個性的結構吸引,只要經過谷中附近,就
一定會來這裡。

　　這一次剛好是晚上,漆黑的大馬路與受到
燈光照射的明亮小路形成強烈對比,當下帶給
我很大的衝擊。

What

I visited this place many times during my walks
around the Yanaka district fascinated by the unique
architecture of the wooden roof ❶ protecting this
small back alley filled with bars.
This time, at night, I'm struck by the contrast
between the dark main street and brightly lit insides.

如何繪製?

　　我小心維持小路內側受到白色燈光照射的
樣子❷,同時利用兩邊的商店和大馬路創造暗
角＊效果❸。如此一來可以吸引人的目光,產
生透視感。為了進一步加強,我特別注意畫面
前方各種元素的細節,還原金屬、磚、水泥的
質感。

How

To achieve the drawing in, depth effect, I was careful
to keep the inside of the alley bathed in bright white
light. ❷ I then made the foreground shops' corners
disappear into a dark vignette. ❸ To amplify this
effect, I carefully recreated the metal, tiles, and
concrete textures in the foreground to make it look
closer to the viewer.

＊暗角:中心比周圍明亮的狀態。

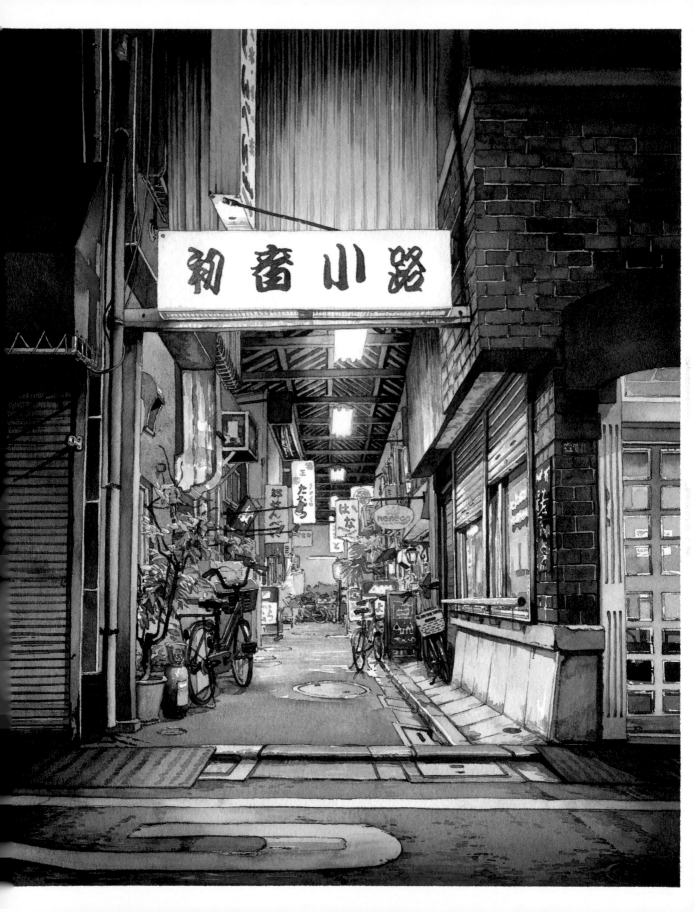

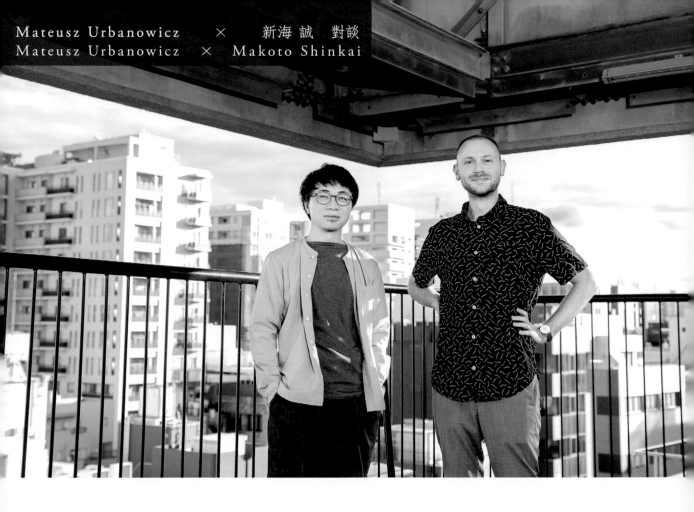

在東京尋找美
Finding beauty in Tokyo

採訪・撰文：高瀨康司　攝影：小倉亞沙子

本書作者 Mateusz Urbanowicz 曾是動畫工作室 CoMix Wave Films 的一員，負責新海誠導演的《你的名字。》等動畫電影的背景美術，離開工作室之後也協助參與新海誠導演最新作品《天氣之子》的主視覺。描繪東京這座城市的作者，與同樣是描繪東京的創作者新海誠導演，針對本作品集的意義和表現方式進行對談。

Mateusz, the author of this book, was a member of the art team of CoMix Wave Films, Inc. studio. While there, he took part in creating, amongst other things, backgrounds for the animated film, *"your name."*, which was directed by Makoto Shinkai. After starting an independent career, he also collaborated in making the key-visual poster for the studio's newest production, *"Weathering With You"*. We follow his discussion with Makoto Shinkai, a fellow creator, who also keeps picturing the city of Tokyo in his works, about the creative expression methods and meaning behind *Tokyo at Night*.

攝於 CoMix Wave Films 總公司的會客室。
At the lounge room of the Head Office of CoMix Wave Films Inc.

用水彩描繪東京的夜晚

──首先請教看完《東京夜行》的感想如何？

新海：非常有趣，引人入勝。一開始可以讓我問幾個問題嗎？

Mateusz：當然，請問。

新海：這些畫全部都是手繪的嗎？

Mateusz：是的。我先用墨水在水彩紙上畫線稿，然後再用水彩筆上色。最後雖然有經過數位編輯調整，但幾乎都保持手工繪製的原樣。

新海：每幅畫都有許多細節，你有先設定消失點嗎？

Mateusz：沒有，我也不畫透視線。由於是手繪，因此我希望保持線條的彈性。我一直在思考，是否能夠用柔和的線條描繪。

新海：我發現你在描繪時採用的視角，不是透過望遠鏡頭，而是更接近實際肉眼看到的景色。

Mateusz：我就知道你會發現（笑）。的確如此。新海先生的作品看起來則是像透過攝影機拍攝的畫面。

新海：嗯，雖然動畫也是手繪的畫，但同時也是影像作品，因此是以類似「鏡頭捕捉到的記憶」為基礎組合完成。

Night Tokyo in watercolor paintings

── First, please let us hear how you liked *Tokyo at Night*?

Shinkai: It was intriguing and fascinating. Can I ask some questions first?

Mateusz: Sure, of course!

Shinkai: Are these entirely hand-painted illustrations?

Mateusz: Yes. I start with a line drawing using waterproof ink on watercolor paper before coloring them entirely with paints and brushes. In the last step, I make some adjustments digitally, but the paintings themselves are entirely done by hand.

Shinkai: These paintings have many very complex passages. Do you draw perspective lines first?

Mateusz: No, I rarely use them. I aim to emphasize the looseness of the hand-drawn lines. I have been trying for some time now to incorporate more organic, loose linework into all of my art.

Shinkai: Also, I notice that in most of the compositions, you appear to be using a viewpoint similar to what we see with our own eyes as we walk around. It's quite different from the images captured through a camera lens.

Mateusz: I knew you would notice this (laughter). Yes, you are right. I remember that unlike these paintings, most scenes in your movies are designed to look like they were shot with a camera.

Shinkai: Yes, even though they too are hand-drawn images. This is because they are, most and foremost,

Mateusz：我也非常喜歡新海先生這種看起來像是透過望遠鏡頭一般的畫面，但這次我希望挑戰全新的事物，營造出身歷其境的氛圍。

新海：視線的高度基本上取決於身高。你的描繪方式讓畫面看起來就好像是我們自己在散步時發現的風景。但用水彩描繪夜晚應該是一件非常困難的事。例如這幅畫的天空（圖❶），從黑到白的漸層，完整涵蓋了這個區域的天空，充分展現東京夜晚的氛圍，非常美麗。

Mateusz：謝謝誇獎。過去在 CoMix Wave Films 擔任背景繪師的工作經驗，在我描繪包含建築物的景色時，發揮極大的作用。

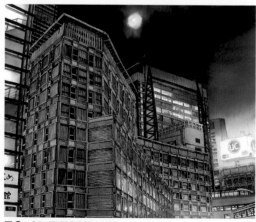

圖❶ 06〈兩個月亮〉26 頁
Pic❶ 06"Two moons" Page 26

pieces of animation — a type of movie. I use the "memories captured with lens" look as a base.

Mateusz: I really like this zoomed-in perspective aspect of your movies. In this book, however, I wanted to try something different that I have never done before. I tried showing the atmosphere of the portrayed places in such a way that would make the readers feel like they are seeing them in person.

Shinkai: So for this, you also used a very natural eye-level. We can feel like we are walking there ourselves, exploring sceneries we just found. I assume it was a challenging task to create night cityscapes with watercolors. For example, look at the sky in the picture (Pic ❶). The color gradation from dark to white is beautiful and thoroughly contained within the area of this sky. The atmosphere of night Tokyo is well expressed here and is very beautiful!

Mateusz: Thank you very much. I have to admit that my experience as a background artist at CoMix Wave Films studio helped much with painting such sceneries full of complicated architecture.

Shinkai: I also notice that in some of your night Tokyo scenes, the sky is as bright as the city. While it is entirely dark in rural areas, in Tokyo, the sky is very bright even at night.

Mateusz: I agree! The bright night sky was one of the biggest surprises that waited for me in the city.

Shinkai: It was a shocking experience for me, too, when I noticed for the first time that the night sky above downtown Shinjuku was actually pink. It made me feel like I was in a different world. Exactly like that, in your paintings, the ground and sky are almost of the same brightness. In animated movies, though, we usually tend to make either the ground or the sky darker so it's easier to tell them apart.

Mateusz: Because in animation, we need to create stronger contrasts.

Shinkai: That's right. In animated movies, one background painting appears on the screen for only

新海：另外，你所描繪的東京夜景，天空的亮度與地上的亮度相同。如果是鄉下的話，天空應該是一片漆黑，但東京的天空即使到了夜晚依舊明亮。

Mateusz：沒錯。來到東京之後，明亮的夜空讓我感到吃驚。

新海：例如，新宿鬧區的天空是粉紅色的，我一開始也覺得好像異世界一般，嚇了一大跳。你的作品都有特別注意地上與天空的亮度是否平衡。動畫的美術簡單明瞭，基本上都會將地上或天空的其中之一調暗。

Mateusz：那是因為必須創造對比。

新海：沒錯。動畫當中，一張背景美術只會出現三至四秒，必須讓觀眾一眼就能立刻分辨地上與天空。因此在製作的時候，我才會要求把天空調亮或調暗。我可能也曾經請你這麼做。

Mateusz：的確如此。

新海：然而，實際上看到的東京夜空比較接近你的作品。透過你的畫，我相信一定會有人發現「啊，沒錯，天空就是這個樣子」。

Mateusz：很高興聽到你這麼說。透過畫作重新認識現實，這是我從上一本作品集《東京老舖》起，就非常重視的主題。

about three or four seconds! Therefore, we have to clearly differentiate the ground and sky so the audience can distinguish them at a glance. That's why I always ask the background art staff at the animation studio to make the color of the sky either consistently bright or dark throughout a scene. I believe I have asked you to do the same.

Mateusz: Yes, you did.

Shinkai: But, the actual night sky that we experience in Tokyo is similar to what you have shown here in your works. I'm sure that when some people see the sky set in paintings like this, for them to notice, some will realize that, "That's right, the sky does actually look like that!"

Mateusz: I'm especially happy to hear that. Ever since my previous book, *Tokyo Storefronts*, it has been an important theme for me to enable people to re-discover their everyday reality through art.

東京的街道與令人懷念的記憶

新海：你來自波蘭對吧？你為什麼會同等喜愛日本昭和時代留下的古老建築物和平成時代之後興建的現代建築物呢？

（昭和 1926～1989 年，平成 1989～2019 年）

Mateusz：與其說喜愛，更應該說是感興趣或覺得有意思。

Tokyo downtowns
and sweet memories of the past

Shinkai: Matt, you are from Poland, aren't you? Then how come you are so strongly fond of both old Japanese architecture that remains from the Showa era and also of modern constructions built after the Heisei era?

(Showa era - 1926 to 1989, Heisei era - 1989 to 2019)

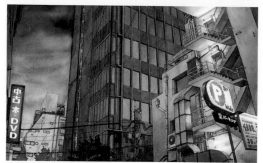

圖❷ 02〈逐漸消失的光線〉16 頁
Pic❷ 02 "The dying light" Page 16

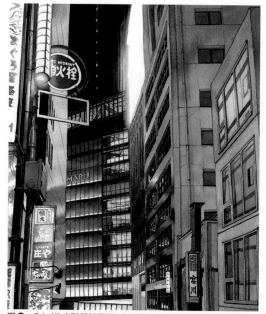

圖❸ 04〈為光影反射著迷〉22 頁
Pic❸ 04 "Captivated by the reflection" Page 22

Mateusz: It is more my interest and attention that have been drawn to them, rather than my thinking of them fondly, to be honest.

Shinkai: I understand that people from overseas find exoticism in the typically narrow Japanese alleys like those in Shinjuku Golden Gai. However, your paintings tend to include ordinary buildings that are just seen all over current Tokyo or things like fire extinguishers or car park signs (Pic ❷ / Pic ❸). These also are undoubtedly unique elements of typical Japanese sceneries, but I'm very interested in how they ended up in your artistic "field of view."

Mateusz: The nondescript buildings, various signs, and things like the unique color gradations of the night sky, which have been mentioned earlier, are precisely some of the aspects of the cityscapes I find compelling and wanted to put into focus in this book.

Shinkai: I see. But still, I feel a little amazed that you, a person from Poland, have been attracted by them. These signs are merely standing there only

新海：我可以理解外國人會覺得如新宿黃金街這般的小路充滿異國風情。但你在作品裡還會描繪現代東京的高樓群，或是消防栓和停車場的標誌（圖❷、❸）等。這些雖然也是個性十足的日本風景，但我好奇看在你的眼裡是什麼感覺？

Mateusz: 這些五花八門的標誌，或是之前提到的天空漸層，是我這次在視覺上特別注意的重點。

新海：沒錯。從波蘭來的你竟然會對這些有興趣，還

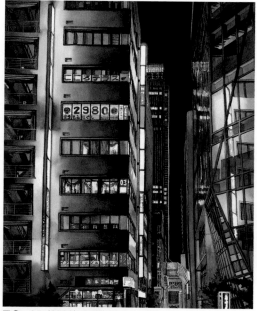

圖❹ 05〈2980〉24 頁
Pic❹ 05 "2980" Page 24

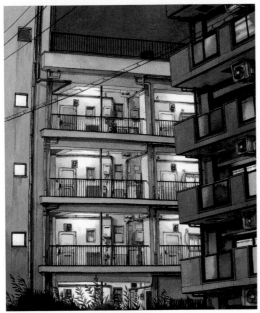

圖❺　12〈沒有人的地方〉52 頁
Pic❺　12 "No one here" Page 52

是有點不可思議。標誌基本上都是因為實用面的理由
才設置，沒有考慮設計或景觀因素。然而，我認為如
果東京少了這些風景，就不是東京。

Mateusz：我也這麼認為。

新海：所以，雖然我與你在不同的國家長大，但觀點
相似。例如這棟大樓（圖❹），每一層樓都是不同的
店家，無論是霓虹燈的亮光或設計，完全沒有統一。
歐洲的街道則大不相同，非常重視景觀。電線不會雜
亂無章地出現在地上，街上的霓虹燈也不會如此色彩
繽紛。

Mateusz：東京的這種雜亂無章，反而吸引了我。

新海：這幅畫也很值得玩味（圖❺）。只是單純的公
寓走廊，沒有特別的主題。然而，卻給人一種回家
的安心感。在你擔任美術人員參與製作的《你的名
字。》（2016 年）中，最後也搭配 RADWIMPS 名
為〈沒什麼特別〉的歌曲，連續呈現了幾張東京「沒

for practical reasons, not for decoration nor design.
They have not been intentionally put there to make
the landscape more attractive. Yet, I also agree that,
without these small details and elements, an artfully
meaningful Tokyo cityscape is not possible.

Mateusz: I believe so, too!

Shinkai: Therefore, I think that you and I have
very similar viewpoints even though we grew up in
different countries. For example, let's look at the
building in this painting (Pic ❹). We can see that with
its multiple tenants, all the floors and shining neon
signs are entirely different — there is absolutely no
design uniformity to it. If we compare this to towns in
Europe, for example, they look very different. Their
design has consideration for the landscape. Electric
wires are not seen just disorderly strung up above
the ground. The neon signs are not as vivid and all
over the place as those in Japan.

Mateusz: On the other hand, I have to say that this
disorder that happens in Tokyo actually felt very
inspiring to me.

Shinkai: This painting is also amazing (Pic ❺). It
shows just a familiar outside corridor of a usual
apartment building without any apparent central
motif, yet it gives us a sensation of comfort — like
that warm feeling that you get when you come home.
In my movie "*your name.*" (2016), in which Matt took
part as a background art staff member, we show
some similar commonly-seen scenery of Tokyo along
with a song titled *Nandemonaiya* (by RADWIMPS).
One of those scenes is a corridor of a typical
apartment building, just like the one in this painting.
It is just an example of a usual Japanese cityscape
that we see everywhere, but I feel a kind of warmth
when looking at it. Matt, what exactly moved you
about this location, so you decided to paint it?

Mateusz: The reason why I chose to paint this might
be connected to an ancient memory that I have. I
clearly remember that one night, when I was still a

什麼特別」的風景。當中便有與這幅畫類似的公寓走廊場景。這無疑是日本的城市風景，我從中感受到溫暖。你也選擇描繪這樣的風景，究竟是哪裡打動了你呢？

Mateusz：這或許與我遙遠的記憶有關。在我還小的時候，晚上坐在車上，開車的人應該是我的父親。我看著窗外，在車燈照射的瞬間，我似乎在暗夜中看到了什麼。至今我依舊記得當時看到了池塘、釣魚的小屋、斜坡等風景。然而現在回想起來，或許這些風景實際上並不存在，只是假的記憶。然而，這些令人懷念的畫面深深地刻印在我的腦海裡。為了這部作品集，我走在街上尋找風景，希望喚起我有點哀傷又令人懷念的記憶，並以這些風景為題材描繪。

新海：想必這幅畫喚起了讓你覺得哀傷又懷念的記憶。在日本，無論是坐巴士或計程車，也都有看過被車燈照亮的小路。雖然這些光景稍縱即逝，但依舊讓我覺得懷念，想像著如果前往那些小路，不知道會發生什麼事情，心情也跟著激動起來。

child, I was riding in a car, probably being driven by my father. Looking through the car window, I think I saw a mysterious scene that kind of burned itself onto my mind. Even now I can recall that I think I saw a small, silent pond and some fishing huts surrounded by a thicket of trees. This was all lit up by bright, cold, solitary lampposts. However, I sometimes doubt if that place actually existed. It can be just a fake memory that I have. Yet, that image remains deep in my heart as a nostalgic scene. For this book, I have tried to walk around the city to find sceneries that give me a similar sentimental and nostalgic feeling. I then created paintings based on them.

Shinkai: I see, so the scenery in this painting brings out the feelings of bittersweet sadness and nostalgia even for you. Sometimes, when riding a bus or a taxi in Japan, we can see glimpses of brightly lit side-streets, right? Although those sights can be seen only for a short moment, they give me a nostalgic kind of after taste too. Such moments make me think that there might be beautiful, exciting stories waiting for me in any one of those bright, narrow alleys. It makes my heart skip a beat.

雨和五感

——在這次的作品集《東京夜行》當中，與「東京」和「夜」同等重要的元素就是「雨」。新海先生也一樣，從《她與她的貓》（1999）、《言葉之庭》（2013），到《天氣之子》（2019），雨都是非常重要的元素。究竟「雨」有什麼魅力呢？

Mateusz：的確多次描繪下雨的場景。

新海：沒錯，理由有好幾個，其中之一是只要下雨，街道的情報量就會增加。例如，日本的地面在平常時候就是一般的柏油路，顏色只有灰色或黑色，但如果光線照在被雨淋濕的地面，立刻就會變得豐富。Mateusz 的畫也是如此（Chapter4〈下雨的東京〉）。不僅是地面，外牆的情報量也會增加。因此我喜歡下雨為街景帶來的變化，讓畫面變得更有趣，這或許就是我持續選擇「雨」當作重要元素的原因之一。

Mateusz：雨天的氣味也令人印象深刻。水泥的味道或潮濕泥土的味道。

新海：聞起來有些像塵埃的味道。另外，除了視覺之外，下雨讓聲音的情報量也增加。例如，車輛在行走的時候，就會加上水濺聲。以前的人會說「觀天望氣」，觀察天空和聲音來預測天氣。現在的人也會說，如果電車走遠之後還能聽到聲音，那就表示要下

Rain and the five senses

—— For this book, *Tokyo at Night*, one of the essential motifs along with "Tokyo" and "night" was "rain." I believe that "rain" has always been a crucial motif also in Shinkai's works. It has been often included in your movies, such as *She and Her Cat* (1999), *The Garden of Words* (2013), and now "*Weathering With You*" (2019). Why do you find it so compelling?

Mateusz: Indeed, you feature rain in your works over and over, many times!

Shinkai: Yes, well, there are undoubtedly some deeper reasons, but one obvious one is that rain boosts the amount of information a city scene holds. For example, the asphalted pavement in Japan is usually just one color — either gray or black. But when a wet pavement shines under sunlight, its appearance changes dramatically — it's suddenly enriched! We can see some of it in Matt's paintings. (Chapter 4 "Rain Tokyo") Moreover, not only the ground but walls of buildings also become much more abundant in information. That's why I like rain as a factor that changes the landscapes of towns and often choose to use it because of how much visual attractiveness it brings to a scene.

Mateusz: A smell of a rainy day is also very unique! It is like the smell of concrete and wet dirt.

雨了。這應該是因為如果空氣中的濕度高，聲音容易傳導。我會被吸引的另外一個原因可能是因為「雨」讓我的五感與世界相連，喚醒我最原始的感覺。

Mateusz：新海先生，你有與下雨相關的體驗嗎？

新海：嗯，我的腦海裡有一個模糊的畫面，但跟你的體驗相同，或許不是真實的記憶。我的老家是位於鄉下的古老日式房屋，我記得在四、五歲的時候，曾經在下雨天的時候一個人看家。我之所以被「雨」吸引，或許與這段過去的記憶有關。除此之外的理由我自己也不知道，所以無法回答（笑）。

讓人想要實地前往的畫

—— Mateusz，你覺得新海先生的《天氣之子》如何？

Mateusz：電影當中東京的景色，最讓我印象深刻的是須賀（圭介）經營的事務所，位於半地下室，看起來非常可愛。

新海：關於那棟建築物，其實不是刻意設計成這個樣子。我以前曾經在倫敦住了一年，幾乎每一棟建築物都有半地下室，景觀上非常統一。但須賀（圭介）的事務所非常東京，只是因為剛好建在斜坡上，所以才變成半地下室。

Mateusz：我在東京散步的時候，多次看到這種半

Shinkai: Yeah, it's a very dusty smell. Besides, rain not only adds more information visually but also enriches the sound aspect of a scene. Even with just running cars, the sound of splashing water makes it more interesting. You know how in old times, people used to forecast the weather by just looking up the sky or by how sounds echoed in the air? This is called 「観天望気」(Kantenbouki) in Japanese. Even now, it is still said sometimes that when the sound of a train can be heard from far away, it will be raining soon. This is probably because sound waves move more easily in the humid air. In other words, I might be attracted to rain because it reminds me that, on a more primitive level, I'm connected to the world through my five senses.

Mateusz: Do you perhaps have an old memory like the one I talked about but instead related to rain?

Shinkai: Mmm, actually yes. Like you, Matt, I am not

sure now if this actually happened, but I recall one distinctive event. When I was either four or five, I remember that I was staying at my family's home on a rainy day by myself. It was an old Japanese-style house in a rural area. This memory may be the reason that I am attracted to rain, though I cannot even say for sure that it's true. Maybe there are other causes that I don't know of! (Laughter)

Pictures that make us want to go places

—— Mateusz, how did you like Shinkai's new movie *"Weathering With You"*?

Mateusz: In regards to the scenery of Tokyo in the movie, the depiction of the Suga (Keisuke) office in the semi-basement impressed me the most. It was very charming.

Shinkai: It's another example of a building that was not designed purposely to look like that. I lived in London for about a year. There, almost all the buildings are designed to feature a semi-basement. This approach creates a uniform look within the street. On the other hand, the building of Suga's office just happened to be placed in the middle of a slope, which resulted in a structure with a semi-basement. This is an example of how things get decided in Tokyo.

Mateusz: I have seen windows of curious semi-basement offices like that while walking around Tokyo many times. They always stimulate my curiosity as I start to wonder "how that place looks on the inside." When I saw a mysterious office just like those revealed in *"Weathering With You"*, it just made me laugh with pleasure.

Shinkai: This is one of the fruits of the efforts of my art staff. Thanks to them, we were successful in creating such an attractive setting. As you said, I believe that if the environment of an animated movie makes the audience consider things like, "What

地下的窗戶，總是覺得「不知道裡面是什麼樣子？」激發我的各種想像。看到《天氣之子》竟然描繪了這種奇妙的窗戶，讓我非常興奮（笑）。

新海：美術人員非常努力，所以才能畫出如此具有魅力的建築物。就像你說的，「不知道裡面是什麼樣子？」、「那條小路的深處不知道是什麼樣子？」、「好想去看看」，讓人興起這樣的想法，就是美術成功的證據。

Mateusz：畫也需要有深度。

新海：不見得畫了許多細節就一定能夠讓人興起這樣的想法。例如你的這幅畫，主角雖然是中央這棟建築物，但或許有人卻想要進去隔壁的大樓看看（圖❻）。我認為這是因為你確實描繪出了這條街的魅力。

圖 ❻　19〈紅色櫥窗〉78 頁
Pic ❻　19 "The red case" Page 78

happens behind those windows?" or "What is there inside that alley?" or "I want to go there," it's proof of an art job well done.

Mateusz: Pictures need depth.

Shinkai: And it's not just merely the amount of details that makes the audience think. For example, let's get back to Matt's paintings. Even if a specific building is the central motif of a picture, some people may feel that they want to go inside and explore the buildings next to it (Pic ❻). This is only because these paintings capture the allure of the city so well.

接受糾葛的情緒

Mateusz：其實，我一邊描繪這部作品集，同時也在心中尋找東京的街道是否「美麗」的答案。

新海：如果不是「美麗」，那你心中是什麼感覺呢？

Mateusz：主要應該是「有趣」、「吸引人」、「懷念」、「特殊」。這一點或許與你不同。

新海：沒錯。如同我覺得藍天、綠地、綿延的高山等自然風景非常美麗一般，我覺得東京的街道也非常美麗。過去在鄉下的時候眺望高山，現在眺望都會大樓的輪廓，同樣感覺很美。

Mateusz：我在觀賞《天氣之子》的時候，想起了過去參與《你的名字。》製作時的我，感受到東京之美。然而，站在人文主義的立場，不禁讓我想要提出批判，這個鋼筋水泥大樓林立的城市，真的適合人類居住嗎？因此，如同宮崎駿先生在《風起》（2013年）描繪雖然反對戰爭，但喜歡戰鬥機的矛盾心情，對於我而言，創作這本作品集，也是為了接受心中糾葛的情緒。

新海：我非常能夠理解你的心情。然而，這裡是人類生活的地方，人類的好與壞、美與醜，就好像馬賽克

To accept conflicts

Mateusz: To be honest, all the while I was painting the illustrations for this book, I was trying to find an answer to a dilemma I had for some time. "Can I say that the city of Tokyo really is 'beautiful'?"

Shinkai: If it's not "beautiful," what kind of feelings do you have towards it?

Mateusz: I always thought about it in terms of being just "interesting," "attractive," "nostalgic," and "unique," but not necessarily "beautiful." This might be where we differ.

Shinkai: Yes, you are right. I think the city of Tokyo is simply beautiful. It is the same way as I feel that natural vistas of clear skies, green grasslands, or mountain ranges are beautiful. I enjoy looking at the cityscapes of Tokyo. I still feel the same kind of beauty as when I was looking at the faraway mountains while I was living in a rural area.

Mateusz: Watching Shinkai's movie "*Weathering With You*", I remembered that I felt a bit of that beauty while painting backgrounds for the previous animation, "*your name.*". At the same time, from a more humanist viewpoint, I cannot help feeling critical about this city filled with concrete buildings. Is this really a place suitable for people to live in? Hayao Miyazaki

一般交錯，我從中感受到美。而我覺得你所描繪的東京非常美。看到你的作品，讓我想要實際前往那個地方。

Mateusz：我也希望看完這本作品的人，如果有興趣，可以實地前往畫中的場景。因此我決定在書中附上外景地圖。

新海：這一點非常令人開心。書中有許多風景讓我想要運用到自己的作品之中。正因為如此，希望今後可以看到更多你所描繪的美麗東京。

expresses a similar feeling of dissonance in his movie called *The Wind Rises* (2013). We can feel from that movie that he is at the same time deeply attracted by fighter planes while still having a strictly anti-war stance. I think that for me, making this book has given me a chance to explore and accept this inner conflict I have.

Shinkai: I understand what you mean well, Matt. I think, however, that precisely because this is a place where people live, it's okay. All the good and bad things about people — all their beautiful and ugly aspects — end up mixed in this city and create that unique mosaic-like thing that I find attractive. Besides, your paintings of Tokyo are so wonderful that they make me want to visit these places.

Mateusz: I also thought that it would be good if this book made people want to explore the city. I made sure to include maps of all the location-hunting walks we had.

Shinkai: Oh, I'm delighted to hear that! I would like to use some of these scenes as locations for my future movies. I am really looking forward to seeing the beautiful city of Tokyo as you painted it.

《東京夜行》製作過程

How it was made

1

原委

「東京夜行」系列一開始由描繪神樂坂和早稻田周邊小路的十張水彩畫構成，既是這本書的原點，也是實驗場。

當時，我想要嘗試在不使用白色不透明顏料（至少部分不使用）的情況下，描繪陰暗的場景。若使用具有穿透性的水彩表現白色，只能在紙上留白不塗色。這種技法不適合用來描繪夜晚街道上遠方大樓的窗戶、街燈、商店看板上的白色文字等微小但明亮的細節。

在我順利完成最初的系列之後，決定以類似的主題出一本作品集。為了決定這次要賦予自己什麼樣的挑戰，於是開始尋找靈感與範例。

吉卜力工作室的作品（宮崎駿導演）和新海誠導演的動畫作品是我在收集資料時最好的起點。另外，過去我曾經在新海誠導演的團隊擔任動畫的背景繪師，當時習得的知識非常寶貴。尤其是動畫常見的「電影式」呈現方式，我希望也能運用到我的作品當中。

在尋找靈感的過程當中，我發現描繪夜景的時候，不見得一定要使用彩度低且帶有藍色調的暗色。無論是哪一位導演的作品，他們的夜景都色彩繽紛，讓人眼睛一亮。

浮世繪版畫，尤其是川瀨巴水的版畫作品，改變了我對於描繪夜景的想法。我多次仔細觀察他的作品，發現就

1

Getting there

A series of illustrations that I called *Tokyo At Night* comprising of ten watercolor paintings of small streets around Kagurazaka and Waseda was the starting point and at the same time testing ground for this book.

At that time I just wanted to test if I can paint dark scenes with watercolors without (or with at least limited) usage of opaque white paint. Because watercolor paint is transparent and one can achieve white details only by leaving the white of the paper unpainted it's not a medium well suited for illustrating night city scenes containing small, bright details like windows of far buildings, street lamps or white text shop signs.

After successfully finishing the first series of illustrations mentioned above, I decided that I would like to make a similarly themed book. The first step was to look for inspiration and examples of art that would help me to decide the overall style of the challenging paintings I had to create.

The works of Studio Ghibli (movies directed by Hayao Miyazaki) and animations made by the director Makoto Shinkai were a good starting point in my search. Also, the knowledge I gained when actually working as an animation background artist as a part of Makoto Shinkai's team was priceless. I wanted to put some of the lonely, "cinematic" look of their animated movies in my works too.

What's more, from analyzing these examples, I learned that painting night images does not necessarily mean using only low saturated, dark and bluish colors — the night scenes from both director's works were surprisingly

連最暗的影子也不是正黑色，而是美麗的藍色和灰色。

我希望在描繪東京時也採取同樣的作法，於是決定在畫線稿、部分暗色薄塗，以及畫影子的時候，使用藍色。

2

尋找適合的工具

與我的上一本作品集《東京老舖》不同，我決定重新思考從風格到畫具的所有一切，不受過去的束縛。我剛好趁著這次機會，尋找並嘗試不同的工具，希望更能夠呈現我所追求的效果。

話雖如此，但我還是使用我習慣的史明克貓頭鷹水彩顏料，共 60 色。混合的顏色越多，彩度就越低，為了快速地用最少的顏色調出需要的顏色，還是必須使用自己習慣的顏料。另外，這個顏料豐富，能夠調出具有深度的暗色，且覆蓋力高。這一點在使用薄塗技法繪製具有透明感的淺色畫作時可能是一個問題，但在描繪夜晚的時候，必須覆蓋畫紙上所有白色的部分，因此使用起來反而非常方便。

這組顏料共有我自己挑選的 60 色（以標準的 48 色為基礎），包含靛藍、印度紅、中性灰等暗色系的顏料。

colorful and bright.

Another art that changed the way I was thinking about painting night views were examples of Japanese woodblock prints — hanga, and especially those made by Kawase Hasui. I browsed his night Tokyo illustrations many times and started to appreciate that even the darkest shadows in his works are not black at all, but beautiful shades of blue and grey.

I wanted to try something similar in my Tokyo paintings, so I decided to use blue color for the linework and some of the dark washes and shadows.

2

Looking for the right tools

Differently to my previous book, *Tokyo Storefronts*, I decided to paint all the illustrations from scratch, so I did not have to follow an already decided style. I was able to search for and experiment with tools that would allow me to realize the look I was looking for the closest.

For watercolors, I decided to use my Schmincke 60 colors set that I'm used to painting with, and that allows me to get many, many colors with a minimal amount of mixing required. The paints produce vibrant, deep colors and have excellent covering power. This can be a problem for more brightly colored illustrations with more transparent washes, but for night paintings where almost all of the white of the paper has to be covered, this was an advantage.

This is a set of colors I choose by myself (building upon the standard 48 colors) containing some beautiful dark tones such as Indigo, Indian Red or Neutral Tinte.
These were very useful because even though I was painting night scenes, I rarely used just straight black paint

這組顏料用來繪製這次的作品集非常方便。主要是因為我向來在畫顏色較暗的場景時，就很少使用黑色，我比較喜歡混合深藍和紅色，調出具有深度的暗色。

這個木箱是自製的，可以收納六十種顏料，方便我在工作室使用。 2-01

然而，我發現描繪藍色的線或影子時，有比顏料更令人頭痛的問題。

不透明壓克力、玻璃筆、色鉛筆等，我嘗試了各種不同的畫具，當我找到輝伯的 PITT 藝術筆時，簡直就像挖到金礦，畫出來的藍色既有深度又具有耐水性。但實際畫在水彩紙上後發現，才畫到一半，筆尖就分岔了。 2-02

最終，我選擇了寫樂的鋼筆，名為「青墨」和「蒼墨」的深藍色墨水，終於畫出我想要的感覺。畫線的時候我會把墨水裝進鋼筆裡，畫影子的時候，則會用水彩筆沾墨水使用。如此一來，我可以畫出與線同色的影子，呈現我心目中接近版畫的效果。

2-02

2-01

preferring to mix my own dark tones with strong blues and reds.

The wooden case was made by me to house all these 60 colors in a small package easy to use in my studio setup. 2-01

The blue lines and shadows proved to be more problematic than the colors. I tried many things, from acrylic gouache paint, through glass pens and colored pencils.
I thought I had struck gold with an artist brush-pen from Faber Castell that should, in theory, allow me to paint waterproof lines of a rich blue shade. Unfortunately, with textured watercolor paper, the pen tip became all messed up after drawing just half of a picture's lineart. 2-02

In the end, it was my discovery of the blue-black inks called Sei-Boku and Sou-Boku made by the Sailor company that made the style I was looking for possible. These inks could be used with regular fountain pens for drawing lines and with brushes for filling in the dark shadows with the same color,

這些墨水是無可挑剔的畫具。重複在水彩紙上厚塗多層也完全沒有問題，擁有完美的耐水性。我也發現如果是薄薄塗上一層，則可以創造出美麗的顏色變化和漸層效果！

這本作品集的所有畫作都是使用顏色更深的「蒼墨」墨水。完成這本書之後，50ml 的墨水已經用掉一半以上。 **2-03**

這次所有的線稿都是使用 Lamy Safari 狩獵者系列 M 尖（筆尖尺寸中號）的鋼筆。無論是保養或維修都非常方便且耐用，工作和日常生活都可以使用。可以輕易更換筆尖，與水彩紙和耐水性墨水的搭配也是一流。 **2-04**

最近在畫草稿的時候，我都是使用波蘭 BIC Evolution 的鉛筆。回想起在我還是小學生的時候也是使用這個鉛筆（當時由 Conté 公司製造），人稱「筆芯不容易斷，最適合小孩子使用」。

2-03

2-04

thus getting me closer to the Japanese woodblock prints look that I was after.

The inks proved to be perfectly waterproof even when used quite thickly on watercolor paper, which was ideal for my purpose. What's more, when diluted, the ink produced beautiful color variations and gradients!

I ended up using the darker blue Sou-Boku ink for all the illustrations featured in this book using more than half of the big glass 50ml bottle. **2-03**

I decided to use the ink with LAMY Safari brand fountain pens with M nibs for all the linework. They are very sturdy, work-horse type pens, easy to maintain and repair if necessary —

even the nib can be replaced very quickly. They worked well with my watercolors paper and waterproof ink combination. **2-04**

To make the underdrawing for the ink lines, I decided to use a pencil I got recently in Poland called the BIC Evolution. I remember using these pencils (originally made by a company

2-05

Evolution 的筆芯很像塑膠，不適合一般繪畫，但在水彩紙上畫起來卻驚人地滑順，且顏色很淡，最適合打草稿。 2-05

我希望尋找中目 300g、紙張紋路不明顯的水彩紙，康頌的莫朗最適合這次我使用的墨水。等墨水完全乾了之後，就能呈現我追求的美麗質感和平面的視覺效果。

很不巧地，這一款水彩紙我找不到適合跨頁印刷的尺寸，於是我在附近的美術行買下店內所有的小尺寸畫紙，把它們黏貼起來後使用。最終，在美術行買的所有莫朗畫紙都被我用完了（我

之後用 photoshop 消去紙張接合的痕跡）。

為了既能夠保持水彩的特徵，又能呈現夜晚的氛圍，最後的潤飾需要幾個技巧。尤其是描繪複雜、細小、明亮的各種細節（白色文字等）和打亮（明亮的的電纜線等）時，我會疊上不透明的白色顏料。在嘗試各種畫具之後，我決

called Conté) when I was still in primary school — these are mostly meant to be used by kids for writing and are supposed to be break-proof.

The core of the Evolution pencil is very plasticky, and so it is not very good for regular drawing use, but at the same time, it glides surprisingly well on the textured watercolor paper and leaves very light marks easy to erase afterward. I think it was perfect for

doing all the underdrawing sketches. 2-05

I tried few watercolor papers, mostly cold-pressed 300 grams ones with slight texture good for flat watercolor washes, but the Canson Moulin du Roy paper worked perfectly with the Sailor ink. The ink washes, when dried thoroughly had that beautifully textured but flat look that I was looking for.

Unfortunately, I was not able to get big enough sheets of this paper for the double-page spread illustration, so I ended up buying up all the stock of smaller sized paper blocks in my local art-supplies store to be sure I have enough for all the pieces. I used almost all of it gluing together two sheets for all the bigger paintings (I would later remove the seam in Photoshop).

2-06

2-07

定使用好賓的白色廣告顏料，在不透明和遮蓋力方面尤其出色。傳統的動畫背景也經常使用不透明的廣告顏料，因此我認為也可以用來描繪水彩畫。 2-06

為了替雨天的東京夜景添加必要的景深和霧，我嘗試使用動畫工作室也經常用到的工具，也就是噴槍。混合幾種水彩，有時也會加入白色墨水，用來營造暗角效果，或是朦朧的光輝。

為了忠實呈現水彩的質感，我特別注意不要過度使用不透明顏料。另外，如果過於依賴噴槍，則會失去畫的細節和光芒，變得平面且單調。 2-07

Finally, although I tried to keep all the paintings as true to their watercolor spirit as possible, I had to use some tricks to add just that bit of night atmosphere. For really delicately thin bright details (like white text) and highlights (like the bright lines of power cables), I had to use some white, opaque paint. From all the paint kinds I tested, I went with the Holbein brand white poster color paint for its superior opacity and covering power.

These paints are also widely utilized for the traditionally painted animation backgrounds, so I felt I could be a bit excused for using them in my watercolor paintings. 2-06

To add some of the depth and hazy look needed, especially in the scenes depicting rainy Tokyo night, I tried another tool used by animation studios — the airbrush. I would use a mix of watercolor paints and sometimes white ink to either make some parts of a picture disappear into a dark vignette or to add a glow of hazy light.

As with the opaque paint, though, I made a conscious effort not to overuse this tool to keep true to the watercolor spirit. Putting too much of the airbrush effect makes a picture lose its details and brilliance, making it dull and flat. 2-07

3

挑選地點（出外景）

在大致決定工具與主題之後，最後就是挑選好的地點。

如果所有的作品都能在現場，而且

在晚上描繪的話，是一件令人開心的事。然而，在描繪大幅且細節繁多的作品時，有時候需要耗費連續四天的時間，因此現實上無法當場作畫。於是我決定晚上到東京的東部地區散步，尋找適合的地點（出外景），拍攝照片帶回工作室當作繪畫時的參考。

大家不妨根據下面這張地圖，探訪我與KANA（有時與本書的編輯或其他人）曾經走過的路。

I. 東京車站附近

第一次出外景，我希望以高樓和有個性的空間為構圖拍照，因此前往東京車站附近尋找適合的地點。 `3-01`

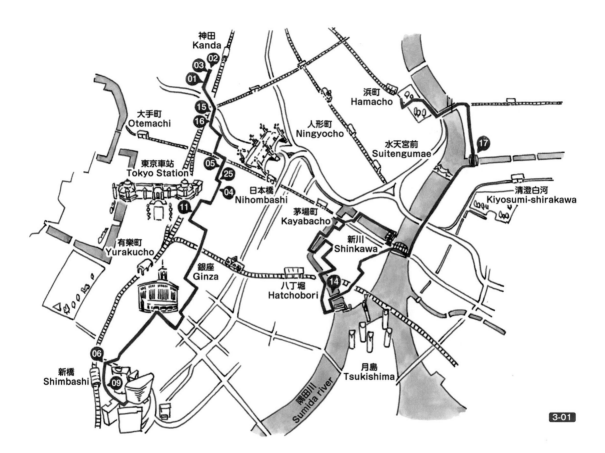

`3-01`

3

Places to paint

After I had decided on the tools and the illustration style, I needed to choose what sights to paint.

As much as it would be exciting to paint all of the pieces on-location, at night,

this was not feasible with big, detailed illustrations that sometimes take more than 4 days of constant, hard work to finish. In the end, I decided on taking location hunting walks around the east part of Tokyo at night to gather materials and then paint using photo references at our studio.

You can follow the paths that I took

with Kana (sometimes joined by other people, like my editor) based on the maps featured here.

I. Around Tokyo Station

The first walk took us exploring the vicinity of Tokyo Station, where I planned to take many photos of high buildings and the unique spaces and compositions that they create. `3-01`

II. 不可思議的有趣小路

第二次的外景，我們從著名的阿美橫町商店街出發，一路走到鶯谷町車站附近，以及有許多老舊建築物和有趣小路的谷中一帶。 `3-02`

III. 河與橋

第三次的外景，我希望在畫中加入更多構造物的元素，因此請編輯帶我去看附近著名的橋。橋、高架橋，以及高處的高速公路，這些是在描繪擁擠的東京時不可或缺的元素。 `3-01`

IV. 秋葉原的雨

正當截稿日一天一天逼近，我伺機準備進行最後一次取景。好不容易等到下雨天，我前往秋葉原周邊，看到許多被燈光點亮的商店，並拍下東京在下雨的夜晚展現的獨特氛圍。 `3-03`

出外景的時候，我用大型數位單眼相機和手機拍了許多照片（手機拍出的夜景出奇美麗）。我拍下所有吸引我的東西，希望重現過去我在神樂坂描繪夜景時的感受——單純畫下平凡，沒有任何不同的的東京夜晚。

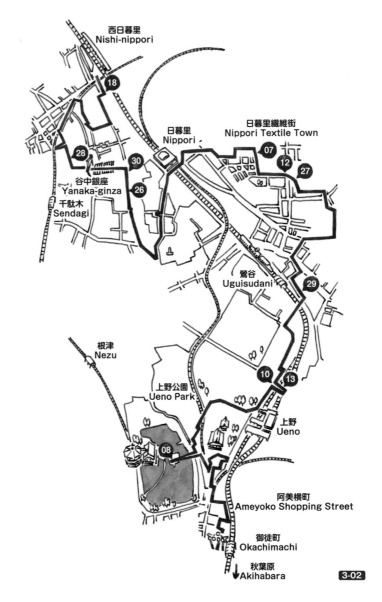

`3-02`

II. Curious side streets
On our second walk, we started exploring from the famous market street Ameyoko Shopping Street, walked around Uguisudani station, all the way to the Yanaka district filled with old buildings and curious alleys. `3-02`

III. Rivers and bridges
This time, guided by our editor, we aimed for some of the most well-known bridges in this area of Tokyo looking for more industrial elements to add to the illustrations. Bridges, high-passes, and elevated highways are a constant element of crowded Tokyo. `3-01`

IV. Rain in Akihabara
As the deadline for finishing all the illustrations was coming closer and closer, I waited for an opportunity to go for our last location hunting walk. And then, at last, it was raining in just the right way so we could go around Akihabara district with its brightly lit shops to document the unique atmosphere of a rainy night in Tokyo. `3-03`

We used a bigger DSLR camera but also our smartphones to take many photos (the phones proved to cope surprisingly well with night scenes) on each of these

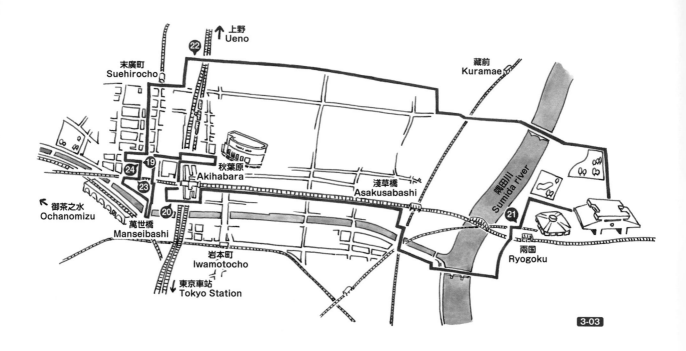

3-03

也就是說，這本書不是單純收集看起來很「酷」的景色，而是希望透過作品記錄我的夜晚城市探險和心情。在某種程度上，我們刻意避免選擇具代表性或過於出名的地點。 3-04

根據至今為止收集的所有素材，經過深思熟慮，我決定描繪能夠展現東京夜晚獨特氛圍的地點或結構，挑選出最

令我心動的三十個場景。我在挑選的時候並沒有設定嚴格的規則。這本書總共有五章，每一章的主題都是在描繪的過程中自然產生。

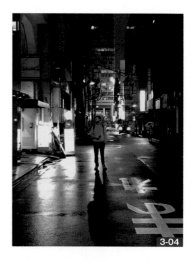

3-04

walks. We just photographed anything that caught our attention to recreate the original feeling of my Kagurazaka night paintings — just regular scenes of walking around at night in Tokyo.

In the end, I wanted the book to be an exploration of the night city and my feelings towards it and not just a

collection of "cool" sights. In a way, we deliberately avoided any places that seemed too iconic and well known. 3-04

From all the materials that we gathered, after much consideration, I chose and painted those thirty scenes that I personally found compelling, featuring

in the book the places and compositions I thought made night Tokyo unique in some way. I did not have any strict rules to guide my choices — even the five themes for the book's chapters came out naturally about halfway into making the paintings.

4-01

4-02

4

作品完成為止

　　一幅畫到完成為止，需要經過多個重要的步驟。

　　首先，根據拍攝的照片，畫出簡單的縮略草圖。我特別留意不要過度受到照片構圖或透視的影響，將重點放在展現我希望傳遞的情感和氛圍。為了決定要突顯畫中的哪個部分，我用鉛筆畫了好幾張不到 8cm 的縮略草圖 4-01 。

　　藉由迅速畫出縮小版的草圖，當感覺畫的構圖不佳，或無法呈現風景獨特性的時候，能夠毫不遲疑地放棄這個方案 4-02 ，只要重新再畫一

4

The process

Making one of the paintings comprised of few essential steps:

First, I would draw a simple sketch of the scene based on the photos we took. I tried not to stick too tightly to the composition and perspective of the photographs and focused on what feeling and atmosphere I would like to convey with the finished illustration. To decide what to feature in the painting, I would do a few small sketches, no larger than 8cm, just with my pencil. 4-01

This way, if I found that the composition didn't work, or the unique element of this scene was not represented enough I was able to abandon this approach 4-02 and start a new thumbnail sketch from scratch without feeling guilty about

4-03

張縮略草圖即可，不會產生浪費大量時間的
罪惡感。

　　等到構圖順利完成之後 **4-03**，接下來
就要準備水彩紙。尤其是在描繪大幅的畫作
時，必須用兩張一樣大小的紙 **4-04a**，黏
合在一起後使用 **4-04b**。由於我這次使用

4-04a

4-04b

wasting too much time.

After I found a composition that worked
well, **4-03** I would get my watercolor paper
ready. I needed to cut the sheets **4-04a** I
had to size and glue two of them together
4-04b for the bigger pictures. This

4-05

4-06

的水彩紙沒有大的尺寸，因此必須自己準備。

等到紙張準備好了之後，看著參考用的照片和最初的縮略草圖，開始描繪詳細的草圖 4-05 。

在畫草圖的最後階段，為了正確複製縮略草圖的比例，有時候也會畫簡單的方格線 4-06 。

然而，關於透視的正確性，我心目中沒有嚴格的規則，有時為了更進一步傳達風景的氛圍，會撒一點「小謊」，故意讓對象物變形。另外，用鉛筆描繪的部分，我一律不用尺。即使畫出來的

inconvenience was caused by the lack of bigger sheets of the paper type I chose to use for this book.

When the paper was ready, I would start to draw the contents of the picture while looking at the reference photos and the first thumbnail drawing. 4-05

For making this final sketch, I would sometimes draw a simple grid 4-06 first to help me with copying the proportions right from my thumbnail sketch.
I'm not very strict when it comes to the accuracy of perspective and would often make small "lies" and distort things whenever I felt like it would help convey the atmosphere of the scene better. I'm also not using a ruler for any parts of the pencil underdrawing. Because of this, the shapes and lines

形狀和線沒有那麼正確，但完成的畫作更有生氣，變得更複雜且引人入勝。

首先，大致畫出大型物體的輪廓 **4-07a**，確認比例，並確保所有的元素都能畫進去。當所有的輪廓都大致畫好之後，小心翼翼地在草稿線上加入細節。我會特別注意不要畫之後很難用鋼筆覆蓋的細線 **4-07b**。

用鋼筆描線時的步驟如下。我使用加了深藍色耐水性墨水的鋼筆，沒有特別注意描繪的順序（因為是防水的墨水，不用擔心會糊掉），一口氣描繪所有的元素 **4-08**。描線的時候，如果有必要，會加入細節，但為了不讓畫看起

are less accurate, but the final picture ends up looking more organic and complex.

I draw the big shapes first, **4-07a** loosely, just to confirm the proportions and to be sure that everything fits nicely in the picture frame. Only when all the main shapes look more or less OK, I start to add details **4-07b** to the sketch, being careful not to overdo them by drawing complicated lines that would be difficult to ink later.

Inking the lines is the next step — I would use a fountain pen filled with the blue-black waterproof ink to draw all the elements of the picture **4-08** in no particular order (as I don't have to worry about smudging this ink). While

4-07a

4-07b

4-08

來太雜亂，我會特別注意不要描繪太多的細節。想要多加描繪的對象越是在畫面的遠方，線條更要簡單樸素。

另外，鋼筆連線條些微的粗細變化都能充分展現，我試著利用這樣的特徵，為畫中的物件增添些許 3D 的特性。尤其是遠方不需要太顯眼的物件（例如玻璃窗後面可以看見的東西 4-09 ）等，藉由線條的不同變化營造層次感。如果擁有重要意義的細節太小，也可以藉由周圍線條的變化，凸顯

drawing I sometimes add more details when I feel they are necessary, but I would be careful not to put too many of them in, not to overcrowd any parts of the image — the further things are in the composition the simpler and less detailed I represent them in the line drawing.

I would also try to use the fountain pen's ability to draw lines of slightly varied thicknesses to add some three-dimensionality to the objects in the picture. Especially with smaller things in the distance or things that have to be less prominent (like elements behind glass windows 4-09) using

the line variation helps a lot to add a bit of depth. If an important detail is too small to be put into the drawing, I try to suggest its existence with the variation of lines surrounding it.

其存在感。

　　有幾張畫，為了想看起來更接近木
版畫的樣子，所以我希望影子能畫得更
平面，且不要太暗。因此，畫影子的
時候我同樣使用墨水，並用筆刷上色
4-10。「蒼墨」的色彩非常美麗，乾
了之後呈現均勻的薄塗效果，因此我用
來描繪漆黑的影子和天空。

　　縮略草圖、草稿、用墨水畫線稿等
作業大約花費一天的時間，複雜的跨頁
作品則有可能需要數日。

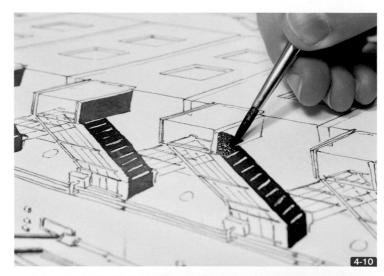

4-10

4-10a

In some of the pictures I wanted to keep
the shadows flatter and not so dark to
follow the woodblock print look — I
would use the same ink for painting in
the shadow areas with a brush. **4-10**
The Sou-Boku ink makes beautiful even
washes when dried on this paper. I was
able to paint flat, dark shadows and
skies with it in some of the pictures.

Usually thumbnailing, sketching and
drawing the lines with ink would take
me a whole day of work, or even
a bit more in case of some of the
more complicated, two-page spread
illustrations.

Before painting using watercolors, I
would carefully erase all the pencil
sketch lines, **4-10a** making sure not

4-10b

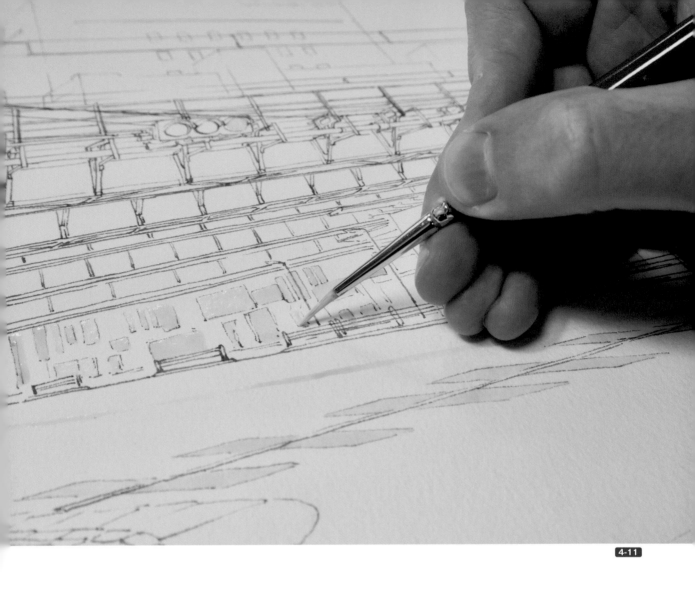

在用水彩上色之前，必須小心謹慎地將鉛筆畫的草稿擦掉 4-10a ，確認紙上沒有任何殘留的痕跡。接下來，在紙張邊緣貼上紙膠帶 4-10b ，將畫紙固定在木板上。如此一來就可以預防在塗色的時候，紙張會因為沾濕而變形。

精緻的白色細節（例如看板上的白色文字等）一不小心可能就會被其他顏色塗滿，因此會在這個階段使用留白膠覆蓋起來 4-11 。

to leave any behind. Then I would apply masking tape to the edges of the picture, 4-10b sticking the paper sheet down to a wooden board — this helps a bit to prevent the paper from buckling when wet during the coloring.

If there are any delicate white details, hard to avoid when painting (like white sign letters, for example) I would use masking fluid at this stage too to cover them. 4-11

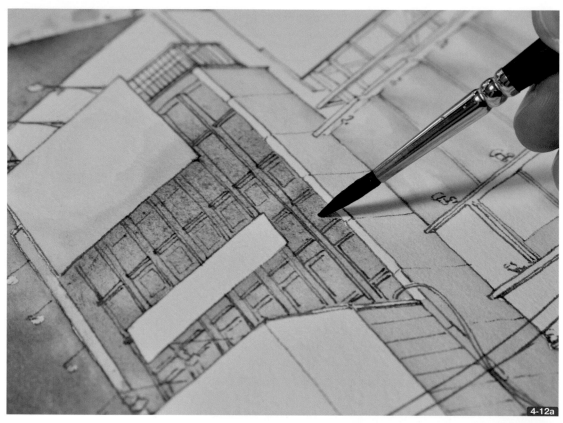

4-12a

接下來是著色。大致上會從最明亮的部分開始上色。例如亮點或明亮的大樓外牆 4-12a 。或者會從窗戶等開始上色，慢慢進入到陰暗部分 4-12b 。

Next comes the paint. Usually, I would start with the lightest parts — like some highlights, bright building walls 4-12a or windows, for example, and gradually progress to darker elements. 4-12b

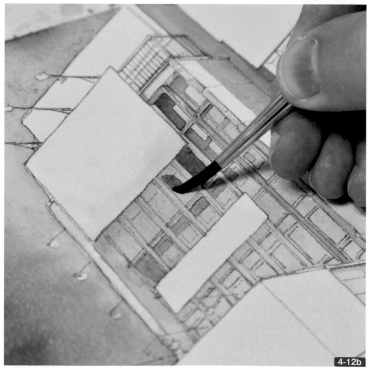

4-12b

然而，本書收錄的作品又大且細節繁瑣，很難遵循這樣的方式上色，有時必須一邊思考一邊作業。如果遇到這種情形，我會把畫分成不相干擾的幾個區，分區上色。

例如，先畫明亮的天空，接下來再塗大樓的顏色，兩者不是同時進行，而有先後順序。從亮的部分慢慢塗到陰暗的影子。

如果亮色細節四周是暗色薄塗（例如黃色文字四周是暗藍色背景），那麼我會再塗上一層留白膠。在乾掉的顏色上塗留白膠，再全部塗上暗色。如此一來可以達到更均勻的薄塗效果，且更能集中精力繪製複雜的顏色漸層。另一個值得注意的是，剝下留白膠的時候，部分顏料也會跟著脫落，顏色會變得更亮，這一點千萬要特別當心。

我把細小精緻的部分留到最後再上

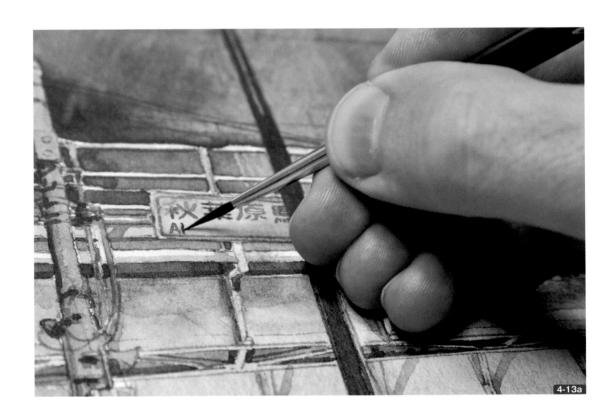

4-13a

Sometimes though, for big, full of details pictures like the ones in this book, such approach is difficult and takes a lot of thinking time, so I would paint in the colors by sections, dividing the picture into regions that should not interfere with each other.

For example, paint in the brighter sky first and then the buildings, not at once but one by one — each starting from the brightest elements to darkest shadows.

On the way, I would use the masking fluid again in places that have bright colored details surrounded by darker washes (for example, yellow letters surrounded by dark blue background). I would put the masking fluid on top of the colors that have already dried and paint darker colors over the whole part. With this approach, I don't have to be so careful and can focus on making more even washes or more complicated color gradations. The only thing is that the masking fluid, when peeled off, takes some of the paint pigment with it making this part brighter than it was before, so one has to keep that in mind.

色。為了不要讓畫過度寫實，同時為了適當展現水彩畫的感覺，我特別注意不要加太多小的點綴。除了描繪看板 **4-13a**、海報、店舖上的文字 **4-13b** 之外，我幾乎不會使用最小號的畫筆。然而，只要細心描繪，還是可以讓畫看起來具有真實性。我在描繪的時候盡量

謹慎，看著參考用的照片忠實呈現。另外，在描繪漆黑背景上的白色文字時，留白膠發揮很大的功效。

由於手邊有參考用的照片，因此這次在描繪之前，我並沒有畫彩色初稿或做顏色測試。然而，我在描繪的過程

中，只要我對顏色沒有把握，即使只有一處，我也總是會在裁剩下的水彩紙上，測試顏色調和的效果。整本作品集，我希望每一幅作品都能呈現稍微不同的色調，因此即使是類似的地方，我也盡量不要使用同樣的顏色。

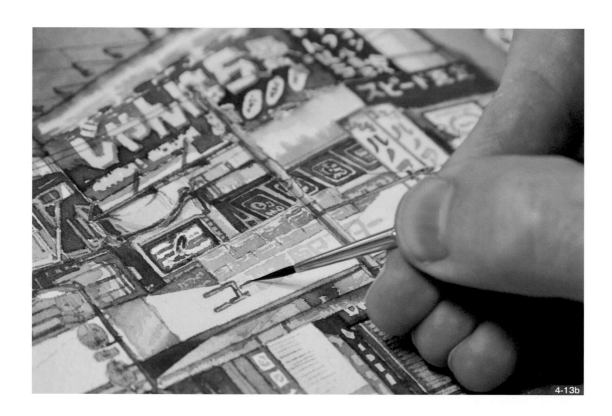

4-13b

I leave the small, delicate details for last. I try not to put too many little touches on the paintings, not to make them too realistic and to keep the watercolor look. I rarely use my smallest brushes, with the exceptions of elements like signs, **4-13a** posters, and lettering on shops. **4-13b** Such elements, if recreated carefully, can bring much realism to a scene. I try to

paint them as carefully and as true to the reference photos as I can. Masking fluid is also really helpful for white letters on a dark background.

As I had reference photos on hand, I did not do any color roughs or tests before painting this time. However, I would test color mixes on a separate piece of scrap watercolor paper while

painting whenever I felt unsure about a particular color. I tried not to fall into a routine — always using the same paints for similar areas throughout the series and made a conscious effort to vary the tones a bit from painting to painting.

With difficult parts, such as complicated reflections, for example, I would proceed with extreme caution to fill in that part,

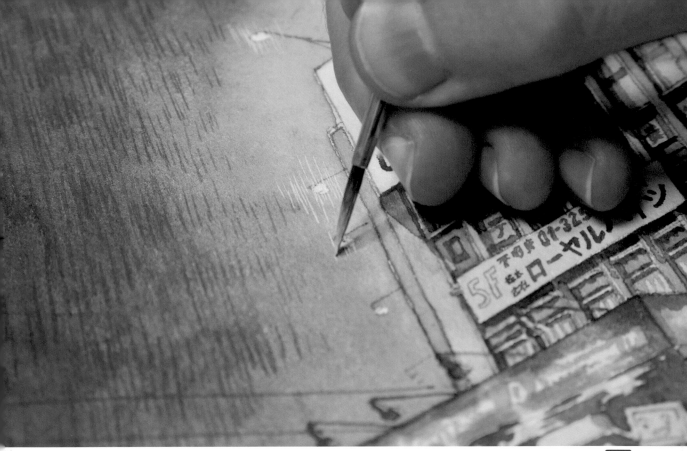

　　即使如此，面對比較困難的部分，例如複雜的反射等，必須一步一步確實地從明到暗，仔細塗色。有時候必須等到整幅畫的八成都完成塗色，才知道效果是否如預期，最重要的是不急躁，慢慢進行。

　　上色的作業需要集中精神，花費一至三天的時間。過程中無論發生什麼事，都必須相信之前的步驟和自身的經驗。基本上，在完成上色之前，都不確定是否順利。

step by step from lightest to darkest tones with due care. Even though it sometimes takes completing about 80 percent of a specific part of the picture to know if the colors will "work fine" above all, I avoid rushing the painting process.

Coloring a whole piece can take me from one to three days of work requiring constant concentration. During that time, I keep trusting the process and my experience even though, usually the painting does not look good until the colors are almost finished.

When the watercolor painting is done, I remove any remaining masking fluid and proceed to add extra touches 4-14 with opaque white paint (poster color or gouache) if needed. I try to keep this to the absolute minimum because details added with opaque paint on top of the watercolors look entirely different from

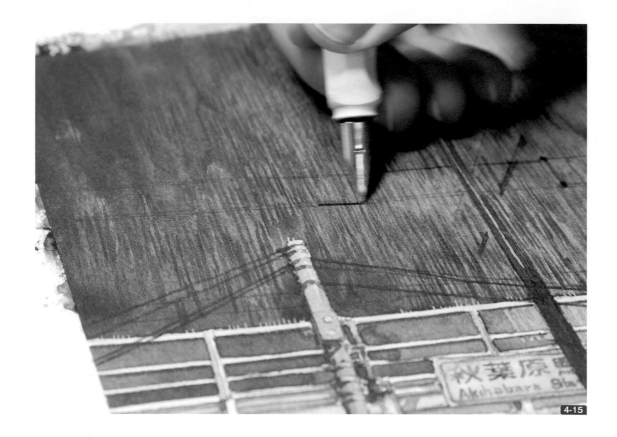

4-15

在水彩描繪完畢之後要去除剩下的留白膠，用不透明的白色顏料（廣告顏料或不透明顏料）加上必要的點綴 4-14。然而，在水彩上面用不透明顏料加上的細節，與不塗色留白的部分看起來有很大的不同，因此盡量將這樣的細節減到最低。我至多用來描繪街燈、亮光四周的白色光暈、鐵絲或如網狀欄杆等細緻的白色線條等。

如果有需要，我也會用鋼筆在水彩上畫線條 4-15。尤其是大樓窗戶的輪廓，有時會畫得比較粗一點。鋼筆在水彩上也能順利描繪，但由於線條黑且較粗，因此我也盡量避免過度使用。

還有幾幅作品在最後潤飾階段，使用了噴槍。

如果想要營造陰暗的效果，我會使用加了暗色顏料（大多是接近藍色的靛色和暗紅色）稀釋的水彩；如果想要描

the white of paper just left unpainted. Usually, I fill in some street lamps, paint white halos around bright lights or add delicate white lines like wires or mesh fences.

If necessary, I also add some ink pen lines on top of the watercolors. 4-15

Especially on buildings, I sometimes make the contours of windows a bit stronger. The fountain pen works well on watercolors, but the line is darker and broader, so I try not to overdo these lines.

With some of the illustrations, I would

use the airbrush for the last painting step.

I would load the airbrush's tank with diluted dark watercolor paint (usually intense blue and dull red mix) for a darkening effect or white Rotring ink mixed with just a bit of watercolor for

4-16

4-17

繪柔和的亮點，我會使用 Rotring 的白色墨水，放進噴槍之後，花時間慢慢地噴塗 4-16 。這樣的作法可以為作品帶來夢幻且安穩的氛圍。

我總是離開自己（或 KANA）的工作桌，戴上防護口罩，在通風良好的地方（浴室）進行這項作業。

最後必須撕掉遮蓋膠帶，確認畫的邊緣都乾淨，才算真正完成 4-17 。

soft highlights. If necessary, I would mask out some parts of the picture with paper and masking tape and delicately, gradually spray just over the intended areas 4-16 to add a bit of that dreamy, soft atmosphere.

I would always do this step away from my (and Kana's) desk, in a well-ventilated space, (our bathroom) wearing a protective mask.

The really final step in making a painting is taking the masking tape off, allowing me for the first time to confirm how the whole piece looks with clean, even edges. 4-17

為了印刷出版，最後的步驟是掃描畫作之後進行數位編輯。為了避免脆弱的水彩畫原稿有任何閃失，因此我都會盡快製作數位化資料備份。

我以 600dpi 的畫素掃描，再於電腦上使用 Photoshop CC 編輯。

編輯作業最初的步驟是將分數次掃描的畫拼在一起。這是因為我的掃描器太小，沒有辦法一次完成。準備跨頁印刷的大幅作品，由於是黏貼兩張畫紙作畫，因此掃描之後，我會盡量消除接合的痕跡（即使接合處在書的訂口位置而看不到）。

大部分的編輯時間，我都是用來修正一些小的失誤，或用「印章工具」消去一些髒污。我盡可能地修掉所有眼之

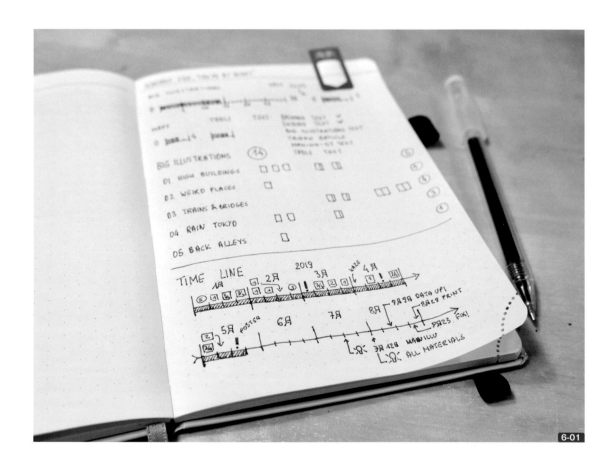

6-01

5

Postproduction

To use the pictures in the book, they have to be scanned and edited digitally—I do it as soon as I can to have a backup "copy" of the picture in case something happens to the original, fragile watercolor painting.

I scan the pictures in 600 dpi and edit the files in Photoshop CC on my computer.

The first stage of the editing process is stitching the picture into one file because the scanner is too small to take an illustration in one go. Also, if the piece was done on taped-together pieces of paper, I try to erase the seam as well as I can (even though this connection should disappear in the book's gutter between pages).

所及的小灰塵、毛髮，不小心沾到的污漬等。

最後，用柔和的筆刷修飾銳角，加上一點點精緻的亮點和影子，微調整體的色調和對比。我特別注意不要過度進行數位編輯，因此刊登的作品得以保有水彩畫原本的氛圍。

檔案儲存之後就大功告成了。將檔案上傳到主機（離線保存多個備份是一件非常重要的事），在進度表上打勾。

6

書本完成

整體而言，製作這樣的一本作品集是一件非常花時間的事。比我當初想像的時間更長。繪製三十幅畫不過是整個過程的「起點」，但由於這是最耗費時間的部分，因此我準備了有助於掌握進度的日程表 6-01 。我也準備了數位的版本，同時與編輯共享，進行管理。

另外，我不喜歡在緊張的日程下，一口氣描繪所有的作品。即使這樣的進度比較快，我還是刻意將作業的時間分開，適度地讓自己從水彩畫的緊張當中解放。

同時，在繪製期間，我也會外出取景或寫文章，收集其他想要收錄在書中的素材等，穿插一些「休息」的時間。

我發現對於我而言，最健康的進度是每個月三到四幅作品。

在繪製的最後二到三個月，我同時與編輯和設計師進行書的裝幀和設計。從排版、使用的油墨、紙張的種類，一直到裝訂，所有的細節都是經過仔細斟酌之後決定。這些部分得到專業人士的幫助，讓人非常安心。

Most of the editing time I spend on fixing small mistakes and erasing any blemishes with the "stamp" tool. I remove any small dust particles, hair, or accidental paint blotches I can find.

Finally, I add just a bit of delicate highlights and shadows with a big, soft-edged brush and adjust the overall colors and contrast a bit. I try not to overdo the digital postproduction, so the picture retains its original watercolor painting character.

I save the file — completing this painting. Time to upload the file to a server (offsite, redundant backups are essential) and cross it out on my progress chart.

6

The book

Overall, making a book like this one takes a long time — usually longer than one expects in the beginning. The main part of making thirty paintings is just the beginning but also the most time-consuming part of the whole project. This is why I like to have an easy to understand schedule sheet in which I can track my progress 6-01 and a digital version to manage the project with my editor.

I also prefer not to paint all the illustrations back-to-back on a tight schedule. Even though I theoretically could paint them faster, I preferred to spread the work over a more extended period, allowing myself a bit of rest from the tense focus of the watercolor painting.

I did work on other things in between paintings. I also used the location hunting trips, writing the text, and making other necessary book materials as breaks.

In the end, I noticed that painting 3 to 4 pieces per month was my optimal limit that allowed for healthy progress until the deadline.

In the final two, three months of making the illustrations, I was also working together with my editor and designer to decide and make the actual book's appearance and design. Every small detail from the layout, ink raster models to the type of used paper requires attention. I was really relieved to work with professionals that helped me with this part.

這是我的第二本作品集，但就「從零開始」這個觀點來說，屬於第一次的嘗試。書中沒有收錄原本「東京夜行」系列描繪神樂坂的畫，所有的作品都是為了這本作品集全新繪製而成。

另外，與我的上一部作品集《東京老舖》不同，我不僅描繪自己覺得有興趣或認為值得保存的場所或建築物，更認真面對東京這座城市存在的本身。我雖然知道這不是一個輕鬆的挑戰，但我不想逃避。

不出預料，這本書的所有元素都非常具有挑戰性。用水彩畫夜景需要細膩的技巧，非常耗費精神。不僅如此，我的情感和想法是連接作品與這座城市的樞紐，更是錯綜複雜。

一開始因為我的這些情感，讓這本書的製作變得非常困難。我覺得，從原本覺得醜陋的事物感受隱藏其中之美，就好像是在作詩吟唱一般。

這或許與我對現代建築的愛恨情仇有關。這樣的情感帶給這座城市或我的作品讓人屏息的未來感，但只要太陽升起，同樣的街道又會變回灰色水泥和玻璃的沙漠。

我在東京的複雜經驗，包括寂寞、喜悅、挫折、成就等，或許影響了我對這座城市的印象。取景、繪製，以及製作這本作品集，這些過程本身就好像是一個過濾網，釐清我的想法與情感。

現在，我似乎已經可以接受這座城市原本的樣子。長時間凝視會發現，這座城市就好像在漆黑處回頭望著我的巨人，笨拙又醜陋。然而，仔細探尋又會發現，每一個角落都藏有獨特又令人玩味的生命力，是一座充滿美麗光景且閃閃發亮的城市。

我是否已經整理好對東京的情緒呢？不，我想並非如此。然而，在作品完成後的現在，我已經沒有必要去思考這樣的問題。接受這座城市原本的樣子，讓我能夠確實向前邁進，透過自己的藝術行動。

我希望這本作品集與上一本《東京老舖》能幫助讀者認識包括東京在內的大城市，進而讓城市更好。

您如果有機會，可以去探索東京的夜晚，體驗一下啟發我創作本書的氛圍。

This book is my second album of paintings but the first one that I decided to make "from scratch." I didn't use the original *Tokyo at Night* series of illustrations about Kagurazaka but painted all these new pieces especially for this project.

Also, I decided on a different approach from my previous book. I did not only paint these places and buildings that I thought interesting and worth preserving. I tried to tackle Tokyo as a whole. I knew that it would be hard for me, but I didn't want to run anymore from this huge thing I had in my head.

As I expected, all the contents of this book were very challenging to make. Of course, the night watercolor paintings were technically tricky, huge, and nerve-racking pieces. But my feelings and thoughts connected to them and to the city they depict were even more tangled and complicated.

These feelings made the book, from the start, really hard to define. It felt more like singing or writing a poem about the secret beauty of something I thought to be ugly.

It might be because of my love-and-hate relationships with modern architecture. I acknowledge that it gives the city and my night paintings a breathtaking futuristic look. But when the sun is up, it turns the same streets into gray deserts of concrete and glass.

It might be my mixed experiences of loneliness, joy, frustration, and fruition that I found in Tokyo that are influencing my image of the city. I tried to use the location hunting walks, painting the illustrations, and making this book as a filter to untangle and study those thoughts and feelings.

In the end, I think that I was able to, in a way, accept the city for what it is. A hulking and ugly giant that, like darkness, looks back into you if you stare at it too deeply for too long. But at the same time, it's also a brilliant city, full of life, every corner unique and exciting. It's packed with beautiful sights if you look for them.

Did I manage to sort out my feelings towards Tokyo? I don't think I did. But after finishing the paintings, I no longer believe I need to. Accepting the city for what it is allowed me to see it more clearly, to look forward, and to take action through my art.

I hope that this book and my previous *Tokyo Storefronts* will allow you to appreciate good things about big cities like Tokyo, and that this will, eventually, make the cities better.

Now, if you have a chance and if you feel brave enough, go and explore the night views of Tokyo. I hope you will be able to experience the atmosphere that inspired me to create this book.

VE0093

東京夜行

Mateusz Urbanowicz 手繪作品集 II

原 書 名	東京夜行 マテウシュ・ウルバノヴィチ作品集 II
作 者	Mateusz Urbanowicz
譯 者	陳心慧
總 編 輯	王秀婷
責 任 編 輯	張倚禎
發 行 人	涂玉雲
出 版	積木文化

104台北市民生東路二段141號5樓
電話：(02) 2500-7696 | 傳真：(02) 2500-1953
官方部落格：www.cubepress.com.tw
讀者服務信箱：service_cube@hmg.com.tw

發 行　英屬蓋曼群島商家庭傳媒股份有限公司城邦分公司
台北市民生東路二段141號11樓
讀者服務專線：(02) 25007718-9 |
24小時傳真專線：(02) 25001990-1
服務時間：週一至週五09:30-12:00、13:30-17:00
郵撥：19863813 | 戶名：書蟲股份有限公司
網站：城邦讀書花園 | 網址：www.cite.com.tw

香港發行所　城邦（香港）出版集團有限公司
香港灣仔駱克道193號東超商業中心1樓
電話：+852-25086231 | 傳真：+852-25789337
電子信箱：hkcite@biznetvigator.com

馬新發行所　城邦（馬新）出版集團Cite (M) Sdn Bhd
41, Jalan Radin Anum, Bandar Baru Sri Petaling,
57000 Kuala Lumpur, Malaysia.
電話：(603)90563833 | 傳真：(603) 90576622
電子信箱：services@cite.my

日文原書製作人員

[装丁・デザイン] 齋藤州一（sososo graphics）
[制作協力] ウルバノヴィチ香苗
[翻　訳] サイトエンジン株式会社

〈対談〉
[聞き手・文] 高瀬康司
[写　真] 小倉亜沙子
[協　力] 株式会社コミックス・ウェーブ・フィルム

[編 集 長] 後藤憲司
[編　集] 後藤憲司、佐々木 梓

美術設計	張倚禎
製版印刷	上晴彩色印刷製版有限公司

2020年7月2日 初版一刷
2023年9月15日 初版二刷
售價 750 元
ISBN 978-986-459-235-7

城邦讀書花園
www.cite.com.tw

Printed in Taiwan.
版權所有・翻印必究

國家圖書館出版品預行編目(CIP)資料

東京夜行：Mateusz Urbanowicz手繪作品集. II /
Mateusz Urbanowicz著；陳心慧譯. -- 初版. -- 臺北市
：積木文化出版：家庭傳媒城邦分公司發行, 2020.07
　面；　公分
譯自：東京夜行：マテウシュ・ウルバノヴィチ作品
集. II
ISBN 978-986-459-235-7(平裝)
1.繪畫 2.畫冊 3.日本東京都
947.5　　　　　　　　　109007117